BLOCK PRINT MAGIC

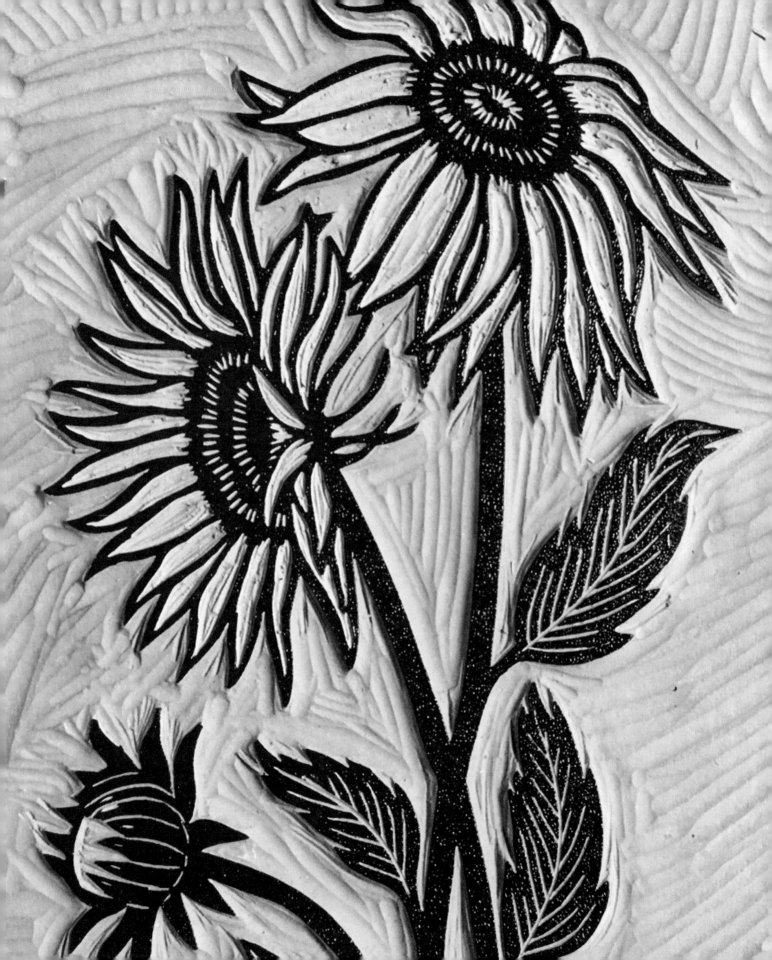

BLOCK PRINT MAGIC

THE ESSENTIAL GUIDE TO DESIGNING, CARVING, AND TAKING YOUR ARTWORK FURTHER WITH RELIEF PRINTING

EMILY LOUISE HOWARD
OF "THE DIGGINGEST GIRL"

ROCKPORT

Inspiring | Educating | Creating | Entertaining

Brimming with creative inspiration, how-to projects, and useful information to enrich your everyday life, Quarto Knows is a favorite destination for those pursuing their interests and passions. Visit our site and dig deeper with our books into your area of interest: Quarto Creates, Quarto Cooks, Quarto Homes, Quarto Lives, Quarto Drives, Quarto Explores, Quarto Gifts, or Quarto Kids.

First published in 2019 by Rockport Publishers, an imprint of The Quarto Group, 100 Cummings Center, Suite 265-D, Beverly, MA 01915, USA.
T (978) 282-9590 F (978) 283-2742
QuartoKnows.com

Rockport Publishers titles are also available at discount for retail, wholesale, promotional, and bulk purchase. For details, contact the Special Sales Manager by email at specialsales@quarto.com or by mail at The Quarto Group, Attn: Special Sales Manager, 100 Cummings Center, Suite 265-D, Beverly, MA 01915, USA.

10 9 8 7 6 5 4 3 2

ISBN: 978-1-63159-615-5

Digital edition published in 2019
eISBN: 978-1-63159-616-2

Library of Congress Cataloging-in-Publication Data

Howard, Emily Louise, author.
Block print magic : the essential guide to designing, carving, and taking your artwork further with relief / Emily Louise Howard of "The Diggingest Girl".
ISBN 9781631596155 (trade pbk.)
LCSH: Linoleum block-printing.
LCC NE1330 .H69 2019 | DDC 761/.3--dc23
LCCN 2018032482

Design and layout: Burge Agency

Photography: Emily Louise Howard, except those in the Artist Spotlights (courtesy of the individual artists) and the following:

Page 30 (upper): *The Plague of Locusts*, published in the *Nuremberg Chronicle*, 1493 (woodcut), German School, (15th century) / Private Collection / Prismatic Pictures / Bridgeman Images DGC875286

Page 30 (lower): *Death and the Ploughman*, from *The Dance of Death*, engraved by Hans Lutzelburger, c.1538 (woodcut) (b/w photo), Holbein the Younger, Hans (1497/8-1543) (after) / Private Collection / Bridgeman Images XJF143243

Page 31 (upper): *House Engulfed in Flames*, 1933 (woodcut print), American School, (20th century) / Photo © GraphicaArtis / Bridgeman Images GRC3035652

Page 31 (lower): *The Gale*, 1894 (woodcut), Vallotton, Felix Edouard (1865-1925) / Private Collection / Photo © Christie's Images / Bridgeman Images CH615511

Page 56—Shutterstock

Page 74 (upper): *Albrecht Durer, aged 56* (woodcut), German School, (16th century) / Private Collection / The Stapleton Collection / Bridgeman Images STC2962079

Page 108 (lower): *Wheatfield with Cypresses*, 1889 (oil on canvas), Gogh, Vincent van (1853-90) / National Gallery, London, UK / Bridgeman Images BAL3585

Illustration: Emily Louise Howard

Printed in China

MIX
Paper from responsible sources
FSC® C016973

For my parents

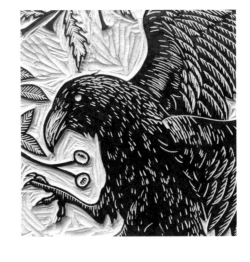

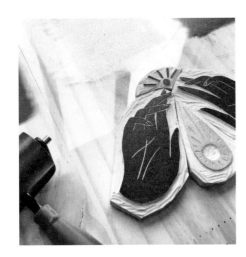

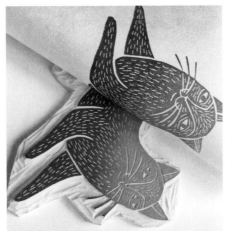

CONTENTS

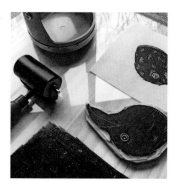

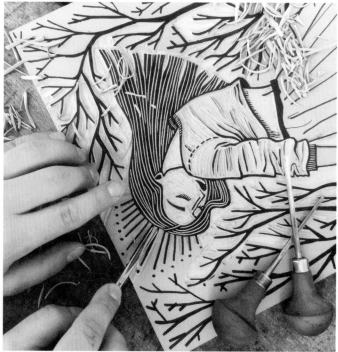

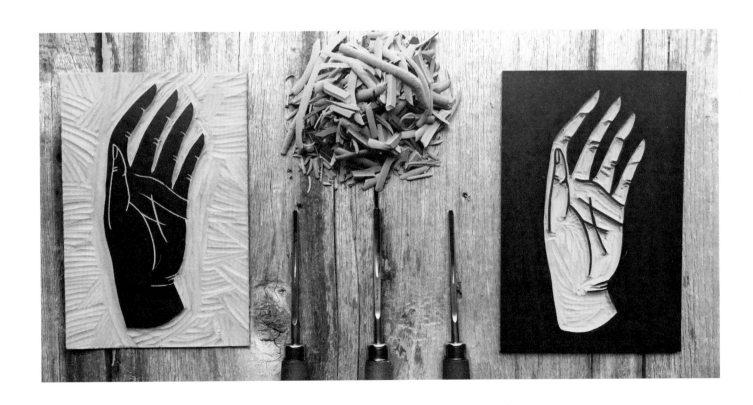

INTRODUCTION

Dear reader,

We're about to make something awesome together. In this book I'll be sharing essential techniques and processes for creating visually captivating linoleum and rubber block prints. I've designed a series of projects to hone your skills and test your creativity, including some fun ways to salvage your mistakes and give mess ups a second life. This book is meant to inspire, encourage, and help you build the skill set you'll need to bring every glorious idea you have to life.

Never picked up a carving tool before? No worries—this book is for you. Dabbled in printmaking in art class, and looking to take your work more seriously? This book is for you, too! In the following pages you'll find useful information on everything from tools and materials to elements of a good composition. I'll show you how to make some of your own studio supplies, such as simple inking plates and drying racks. Each printing project is designed to focus on a specific skill or skills—from basic textures to multi-block prints to rainbow rolls and everything in between. We'll also meet a handful of printmakers from across the United States who graciously share their experience and secrets to help us along. No matter your own art history or skill level, there's something for you here.

My own background as an artist is interdisciplinary: my roots are in classical drawing and painting from observation, and I found printmaking relatively late in my education. I treat sculpture like a creative palate cleanser, and love tweaking designs for woodworking projects. I practice embroidery as a form of stress relief. Each discipline informs the other. The painter has something to learn from the sculptor, just as the football player has something to learn from the ballet dancer. It is my dearest hope that you'll be able to learn something from me.

And now it's time! Test the weight of the carving tool in your hand and feel the tingling sensation of *possibilities.* Listen for the kiss of the brayer as it rolls out the ink. Let some choice swear words slip in tandem with your V-gouge (hey, it happens to all of us). Make plenty of mistakes, stab yourself once or twice, learn your lessons, and then revel in your first perfect print. Pull something into existence by the force of your own will. There's magic to be made here.

Yours in inky solidarity,

Emily

ESSENTIAL TOOLS AND MATERIALS

In this chapter, you'll learn about the basic materials needed to take you from bright idea to successful linocut print. Linocut printing is a form of relief printing, the process of pulling a print from a carved block, where the ink is deposited on the remaining (uncarved) areas of the block. One of my favorite things about relief printmaking is that you don't need expensive equipment to make studio-quality prints, and most tools are relatively affordable. There are lots of brands of tools, papers, blocks, and inks to try, so research and experiment to find what works best for you.

ESSENTIAL TOOLS

Blocks

CARVING BLOCKS

Though printmaking encompasses many different types of carving surfaces, this book focuses on the use of linoleum and rubber blocks. Soft rubber is often a good choice for younger, less experienced printmakers as it is easy to cut with beginner's tools. I also prefer soft rubber when printing on fabric. The sturdier linoleum is harder to cut and requires sharp tools but its density holds detailed cuts beautifully, and it is less likely to accidentally squish and bleed during printing.

LINOLEUM BLOCKS

Made of linseed oil, cork dust, wood flour, and pine resin, linoleum is a medium that many artists choose to work in because of its renewable composition. It comes in a variety of small-to-medium standard sizes as well as in large rolls, and due to its flexibility it can be cut into any shape. Many professional printmakers prefer the unmounted "battleship gray" linoleum.

Linoleum sometimes comes mounted on thick blocks of composite wood and although these can't be easily manipulated into different shapes, the wooden backing provides extra support and protection for your carving. The weight of the mounted block also helps to keep your carving stable when you peel off the print.

Linoleum (mounted or unmounted) can be heated to help carving tools move through them more smoothly: you can do this by covering the block with a towel and gliding over it with a clothes iron on a medium setting. Or you can simply warm it with a hairdryer. I personally find that sitting on a block heats it up just enough. If you keep your carving tools sharp, however, you may not need to heat your block.

Linoleum should always be stored flat, away from direct sunlight and extreme temperatures. Light, extreme temperatures, and time will eventually cause your linoleum to become hard, warped, crumbly, and infuriating to carve. I don't keep much linoleum on hand because fresh linoleum cuts best.

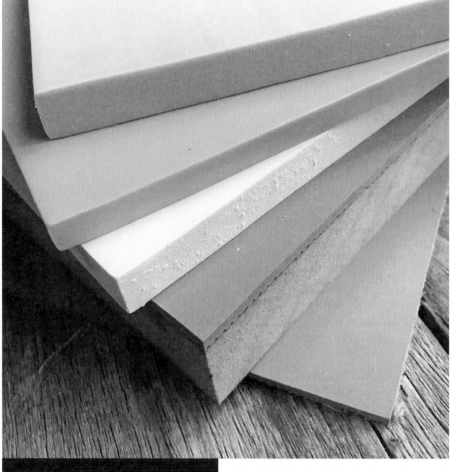

From top to bottom: MOO Carve Professional Carving Block; Speedball Speedy-Carve; Speedball Speedy-Cut; Speedball mounted linoleum block; Blick battleship gray unmounted linoleum.

RUBBER BLOCKS

Rubber blocks such as Soft-Kut, MOO Carve, and Speedy-Carve are a good alternative to traditional linoleum: they're generally much softer and easier for the blade of your carving tools to bite into. It takes only a fraction of the power necessary to push a blade through linoleum. The softest of the blocks, like MOO Carve, require only the lightest flicks of your blades so a steady hand is very helpful. Rubber blocks are great for detailed work and won't get crumbly as linoleum sometimes does.

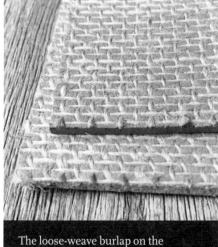

The loose-weave burlap on the back of unmounted linoleum, also referred to as the hessian backing.

Carving Tools and Tool Care

Most starter kits come with a variety of blade widths and shapes, ranging from the narrowest veiners to the widest U-shaped blades. Veiners are for making very thin, fine lines. V gouges are formed at either 45- or 90-degree angles. U gouges are—you guessed it—shaped like Us, and are great for scooping out lino cleanly. You should also consider the size of your hand and the type of handle that will give you the best grip—full-size tools can be harder to wield but provide greater leverage for more power behind your cuts. Mushroom-shaped palm tools can provide a more comfortable, stable grip for carving fine details.

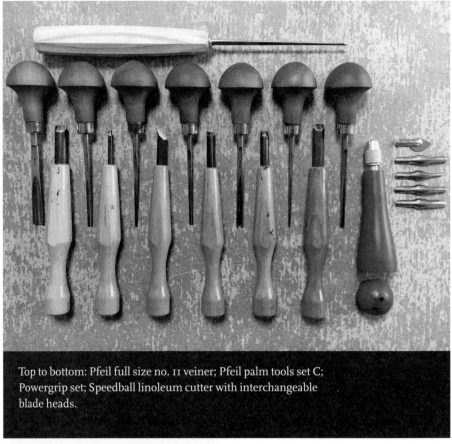

Top to bottom: Pfeil full size no. 11 veiner; Pfeil palm tools set C; Powergrip set; Speedball linoleum cutter with interchangeable blade heads.

Pfeil Swiss-made carving tools, set C

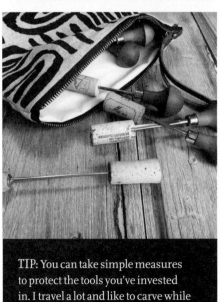

TIP: You can take simple measures to protect the tools you've invested in. I travel a lot and like to carve while on the road, so I pop an old wine cork onto the end of the blades to protect both the blades and my fingers.

Though I keep many tools at hand, I usually end up reaching for the same four tools over and over again: a 1-mm U gouge, 3-mm U gouge, 1-mm V gouge, and a 0.5-mm veiner. Those are my workhorses, suitable for most projects with fine details under 11" x 14" (28 x 35.5 cm).

The density of your linoleum has an impact on your tools. Dense battleship gray lino will dull a blade much faster than its soft rubbery counterparts. Because your blades will take a beating just from regular use, it is worthwhile to buy the best quality blades you can afford. However don't discount the cheaper starter sets—they are perfect for beginners and some have interchangeable blades that you can conveniently store in the handle of the tool itself.

Sharpening Your Tools

Over time, the blades of carving tools lose their edge and become dull. A dull blade is a printmaker's nightmare, because it is more difficult to push through linoleum. This will cause you to tire quickly and also makes the blade more likely to slip or tear the linoleum. A good practice is to sharpen your blades regularly to keep them free from nicks and burrs, which are rough little bits of metal that can form on the edge of the blade. And to any art student who had to endure the struggle of carving with a raggedy tool used by a hundred other students that semester, this one's for you.

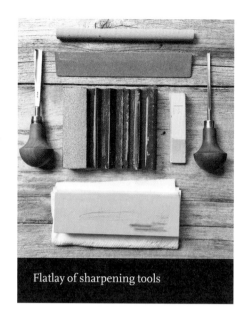

Flatlay of sharpening tools

Using a Slipstrop

Here is how to hone your tools using the Flexcut SlipStrop.

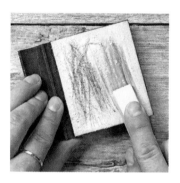

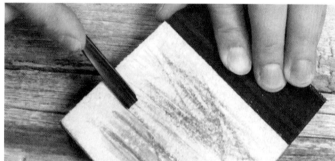

1 Start with sharpening the outside of the tool. Rub the yellow honing compound (included with the set) onto the flat side of the slipstrop, applying it to the leather surface liberally.

2 Hold the tool at about a 15-degree angle and place it on the leather, pointing away from you. Pulling it back toward you, gently push the outer edge of the blade against the leather. If you're sharpening a U gouge, start on one side of the gouge, and roll it to the other side as you pull it back toward you. Rolling the tool gradually from side to side ensures that the entire edge makes contact.

3 If you're sharpening a V-parting tool, do one side at a time instead of rolling. Don't rub the tool back and forth; pick it up and place it at the top of the slipstrope for each stroke.

4 Flip the slipstrop over to reveal the funky, ridged side. These curved and steepled ridges correspond to the shape of most gouge tools. Select the ridge that matches your blade and rub the yellow honing compound liberally along it. Repeat the same process for the inner portion of the blade as you used on the outer edge.

Using a Whetstone and Slipstone

1 Submerge the whetstone in water for 5 to 10 minutes before use. Place on a paper towel.

2 Hold the tool against the blue side of the whetstone at about a 15-degree angle (or so that the cutting edge is flush with the surface of the stone). If you're sharpening a V-parting tool, gently move it up and down against the stone about 5 times or until you see the edge start to sharpen.

3 If you're sharpening a U-gouge, rock the tool by turning your wrist as you move it left to right.

4 Run a slipstone, also called an Arkansas stone, along the inside curve of the tool, pushing the stone out toward the blade edge. Use a rounded stone for U gouges and a pointed one for V-parting tools.

5 Flip over the whetstone and repeat the process on the finer-grit side to further hone/finish the blade.

Brayers, Barens, Plates, and Knives

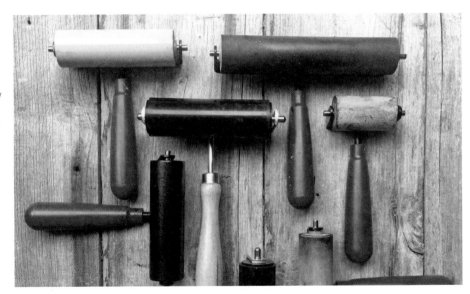

BRAYERS

Brayers are rollers used to evenly spread ink onto the surface of a carved block. They come in a variety of sizes and are made of either hard or soft rubber. The hard rubber brayers are great for coaxing out fine details, and soft rubber brayers apply ink very uniformly across a block. You hardly need to exert any pressure to apply ink to the block with a soft rubber brayer.

Consider the size of the block you'll be printing when selecting a brayer. Ideally, the brayer should be slightly wider than the shortest side of the block. This will allow an even application of ink without any stray marks left by the edge of the roller. The brayer should also be smooth, without any bumps, dents, or ridges in the rubber roller, as these imperfections in the roller will transfer directly to your print. Keep your brayers clean of ink when not in use and store them so that the rubber roller isn't touching anything.

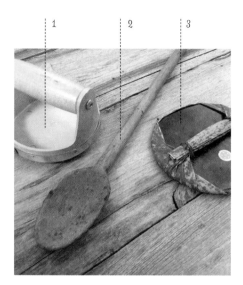

INKING PLATES

Every printmaker needs an inking plate or platen, which is a clean, smooth, nonporous surface on which to mix, spread, and roll out ink. Various materials can be used as an inking plate, such as a metal tray, metal bench hook, a piece of safety glass with a beveled edge, or a piece of plexiglass with the edges sanded or taped. I made the inking plate featured in this book simply by screwing a piece of plexiglass to a similarly sized wood board. It helps when the inking plate is heavy or anchored, as inks are tacky and can sometimes cause the plate to stick to the brayer. Always clean your inking plate immediately after finishing a print run, as dried ink on the plate will keep you from getting an even application of ink the next time you use it.

BARENS

A baren is the essential tool for hand pulling a successful print: you use it to burnish the back of the paper on your inked block. This tool allows you to apply even pressure across the block without ripping holes in your paper. The most readily available (and not to mention inexpensive!) baren is a simple wooden spoon like mine (see 2 in the photo). A smooth, hard surface is really all you need! Steer clear of metal spoons, as the friction needed for printing causes them to become hot. Hold the spoon near the top, putting the pads of your index finger and middle finger in the bowl; this will give you a stable grip and sufficient leverage to burnish your paper.

Traditional barens intended for Japanese woodblock printing are covered in bamboo leaves that make up the handle (see 3). Over time, the bamboo will wear out and need to be replaced.

The Speedball brand baren (see 1) has a higher handle profile and plush pad. I find this works great for printing with softer rubber blocks.

Burnish: To buff or rub

PALETTE KNIVES

An essential tool for preparing ink is the palette knife, or spatula, used to scrape ink from its container and spread and mix it on the inking plate. Palette knives come in a variety of shapes and degrees of flexibility. If you plan to do large print runs, which involves pulling many prints in the same session, a wider knife would be appropriate for mixing and spreading large amounts of ink. I prefer flexible knives with rounded edges, as I'm less likely to scratch my inking surface.

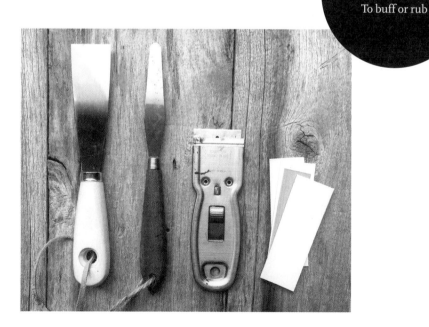

ESSENTIAL MATERIALS

In addition to the right tools, every printmaker needs ink and paper. Each type of ink yields a different result, and the paper options today are seemingly endless. Read on to learn about ink, paper, and a handful of other materials that will round out your toolkit.

Tack:
A physical property of ink that describes its stickiness

Inks

Choosing the right ink is an important part of the print process, and there are many considerations to be made. It's important to use ink that is specifically formulated for relief printing, as opposed to just using any old paint or ink. Paint will ruin your brayers and blocks. The right inks will extend the life of your block as well as look gorgeous on paper.

WATER-BASED INKS

Water-based inks are a good choice for beginners and kids, and when you have to print in crampled conditions, because they clean up easily with soap and water. Also, they are fast-drying, which is nice when you're short on time or if you run a small edition of prints. However, water-based inks tend to have a flaky appearance upon drying and are often difficult to roll evenly over the block.

> TIP: Ink stored in tubes is less likely to dry out, as air is less likely to be trapped inside throughout use, but less economical than ink sold in tins.

OIL-BASED INKS

There are two kinds of oil-based inks: those that require solvents for cleanup and those that are water soluble/washable. Both yield equally velvety finishes and hold strong, vivid color. Solvents such as turpentine and kerosene are the most efficient cleaners of oil-based inks, but are quite toxic. A safer cleanser is plain old vegetable oil. Simply saturate a paper towel and wipe. This tends to leave a residue on the block, so I usually follow up with a disinfectant wipe. My favorite ink of this variety is Gamblin Relief Ink.

Water-soluble oil-based inks are made with vegetable oil. Wonderfully nontoxic, these inks are vibrant and have a tack that makes for uniform coverage. They're easy to clean up with soap and water or disinfectant wipes. Caligo Safe Wash Relief Inks are a great choice, and were used for the majority of the projects in this book.

INK MODIFIERS

There are many different kinds of additives that you can mix into your ink to achieve different results. Adding a drop of cobalt **drier** to ink will significantly speed up the drying time of your prints. Cobalt drier is quite toxic, however, so handle it with gloves. Adding **extenders** or **transparent base** will dilute the color of the ink without changing its viscosity—think of it as turning down an ink's opacity.

Adding **retarder** will slow down the drying time of the ink, which is nice if you like to work slowly or you're pulling a large number of prints. However, keep in mind you'll need to keep your prints in the drying rack a little longer, too.

Papers

Although, technically, you can print onto nearly any flat surface, the cheapest, easiest, and most widely available surface is paper. There's something so tactile and rich and just plain *pleasant* about rubbing a decadently thick sheet of gorgeous paper between your fingers. Lucky for me (and you too) there are many different kinds of paper on the market today. The most common ingredients in artists' papers are wood pulp, cotton rag, pulped linen, and mulberry/kozo—all are great choices for printing linoleum blocks by hand. It's fine to use any old paper when you're learning in your own home for fun, but you'll find that the higher quality paper you choose, the better your prints will be.

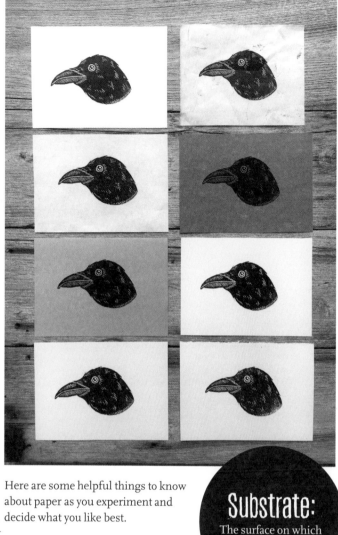

Here are some helpful things to know about paper as you experiment and decide what you like best.

Substrate: The surface on which a print is made

ACID FREE AND ARCHIVAL

The ideal papers to use are free of lignin, an acidic substance in wood pulp that causes paper to yellow and turn brittle over time. Paper that is acid free is known as archival, which essentially means that it will last a really long time. One hundred percent cotton rag paper is naturally acid free and is a great choice. Professional printmakers are sure to select archival, acid-free papers to ensure their artwork lasts for many years.

WEIGHT

The weight or thickness of a given paper is measured in grams per square meter (gsm). The higher the gsm, the thicker the paper. You can use papers of all thicknesses in relief printmaking, depending on the type of inks and blocks you use and the final look you hope to achieve. Thinner papers are great for printing by hand, but they can sometimes lack the luxurious feel and look of thicker papers. Some handmade papers have lots of texture that can drastically affect the evenness of a print. Try out a wide variety of papers, and you will come to learn which works best for you and your specific project.

HOT PRESSED AND COLD PRESSED

Machine-made papers pass through a series of metal cylinders that are heated and compressed or cooled and more loosely compressed to create different textures. Hot-pressed paper has a smooth surface with a fine grain. Cold-pressed paper has a slightly toothier, or more textured, surface.

MISCELLANEOUS EQUIPMENT

Drawing Materials

Sketchbook

Pencils

Pencil case

Eraser

Black permanent markers

Tracing paper

Drafting brush/duster

Carbon paper

Other Useful Materials

Apron

Boxcutter

Scissors

Roll of butcher/kraft paper

Washi or masking tape

Ink scraper

Mat board strips

Disinfectant wipes

Paper towels

Pumice soap

Mixed Media Materials

Craft knife

Self-healing cutting mat

A yard (1 m) of unbleached 100% cotton duck (also known as duck cloth)

Basic sewing kit (needle set, all-purpose thread)

Embroidery hoop

Embroidery floss

Embroidery needle

Set of gouache or watercolor paints

Palette, water cup, paintbrushes

Bone folder

Adhesives

A Note on Adhesives

You'll need to join paper to paper for multiple projects in this book, and using the wrong adhesive can be disastrous for the fate of your prints. Some glues can cause papers to warp, wrinkle, turn yellow, and deteriorate. PVA glues, however, are acid free and will not yellow over time. They dry clear and remain flexible. Yes Paste and Nori Paste are both good options, as they are slow-drying (giving you more time to position your work) and won't cause excessive buckling of your papers.

ANATOMY OF A PRINT STUDIO

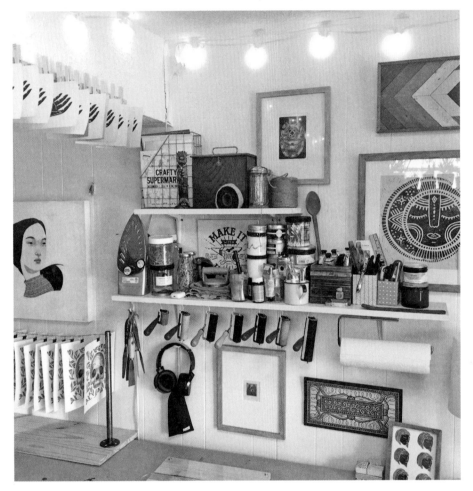

Now that all of your materials are sorted, the next challenge is finding the space to do it all. I recall the following quote by Joseph Campbell as I set up my studio space in my home:

"[A sacred place] is an absolute necessity for anybody today. You must have a room, or a certain hour or so a day, where you don't know what was in the newspapers that morning, you don't know who your friends are, you don't know what you owe anybody, you don't know what anybody owes to you. This is a place where you can simply experience and bring forth what you are and what you might be. This is the place of creative incubation. At first you may find that nothing happens there. But if you have a sacred place and use it, something eventually will happen."

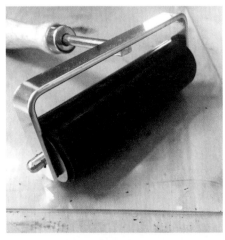

The studio is a world apart from politics, bills, and the million tiny worries that bombard me throughout the day. It's a place where magic lives—I just have to show up and activate it. But first I have to invite the magic in. My own humble space boasts of an awkward L-shaped layout with a lot of homemade equipment, dotted with too many stacks of paper. But it is heaven on earth to me. You don't need a studio that rivals one you'd find at the Rhode Island School of Design and it doesn't need to make Martha Stewart turn green with envy. The main goal of your creative space—whether it is a separate room, alcove, or just a temporary tabletop—is to make the print process as efficient, comfortable, and inspiring as possible.

An efficient studio layout starts with consideration of the activities you'll be performing, in my case, the basic steps to pulling a print:

Drafting designs

Carving blocks

Inking

Printing

Drying

Storing

The whole point of the studio is to be a space that is exclusive to artmaking, but sometimes you don't have the luxury of having a whole room to yourself. The good news is that all you really need is one good-sized tabletop and a few key pieces of equipment. When planning your space, consider the following needs.

1. Clean space

For drafting designs, preparing printing papers, and carving blocks and signing prints. Keep this area completely free of ink in order to preserve the cleanliness of your papers. It would be sad to pull a five-color print only to ruin it with a big stray ink smudge picked up from the table!

2. Dry space

A place to keep your wet prints as you pull them. DIY drying rack plans can be found on page 26.

3. Print space

This is the area where you'll print your inked blocks. I like to cover this area with butcher paper and tape it down to the table for easy cleanup after a project. This is also where you will put any registration device/printing jig (see page 43) you may be using for your project. Keep a mini-clean zone above the jig so that there's a safe place to stack your prepared papers.

A simple set up

Potential tabletop layout

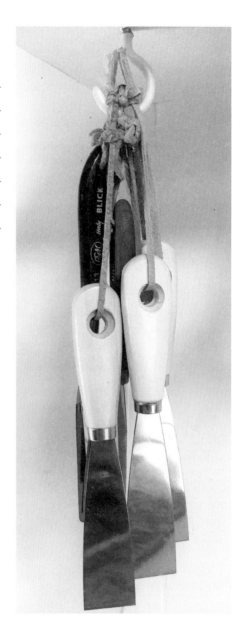

4. Ink space

For making a mess! This is where your inking plate lives for mixing, rolling out, and applying ink to blocks. On one of my studio tables, I have a large sheet of plexiglass screwed directly into the tabletop as a permanent ink surface.

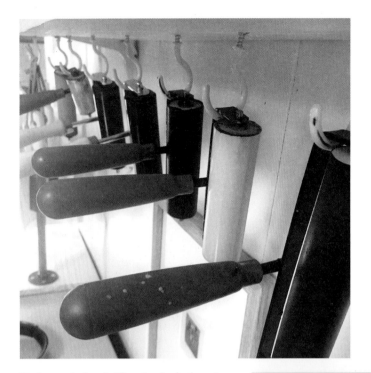

Blocks that have already been printed, cleaned, and dried are stacked in milk crates, with titles visible for easy access

Underneath the shelf are hooks for hanging my brayers, which further help to corral the ink. Hanging brayers keeps the rubber roller from becoming dented or otherwise damaged over time. I also keep all of my essential ink cleaning supplies within easy reach: a roll of paper towels, a container of cotton swabs, disinfectant wipes, mat board strips, gloves, baby oil, a stack of old magazines, and a garbage can, which is tucked under the table.

TIPS:

Printmaking is physically demanding and can be punishing on the body—especially the shoulders, neck, and back. Adjust the height of your workspaces to ensure that your body won't tire out too quickly from hunching over. I keep a dense foam roller under my work table to stretch my back and give it a break during long print sessions.

Plan the arrangement of studio furniture around the light and your dominant hand. Try to keep your work table as close to a window to allow maximum natural light. I'm right handed, so when my light source is to my right, my hand casts a shadow over my work. If I light my workspace from the left, I can see my work more clearly.

If you have trouble seeing detail, you may want to invest in a magnifying glass as used by miniaturists. They come in many different models, but you can get them either freestanding or equipped with a vise grip to attach to your tabletop.

Hang or shelve as much equipment as possible to keep your workspace clutter free. Now when the muse strikes, there's nothing to get in your way!

Surround yourself with things that inspire you. This could be anything from your geode collection to movie posters to children's drawings to postcard reproductions of famous paintings—as long as it makes your brain start turning and your fingers start itching! I've outfitted my studio in framed prints collected from friends and artists I admire. They keep me in good company even through those long hours solo in the studio.

Flat files work best for storing prints, but a regular chest of drawers can work in a pinch, too. Stored prints are happiest when they're flat, dry, and dark. This will help maintain the pigment quality of printed inks and keep papers from becoming warped or curled due to overexposure.

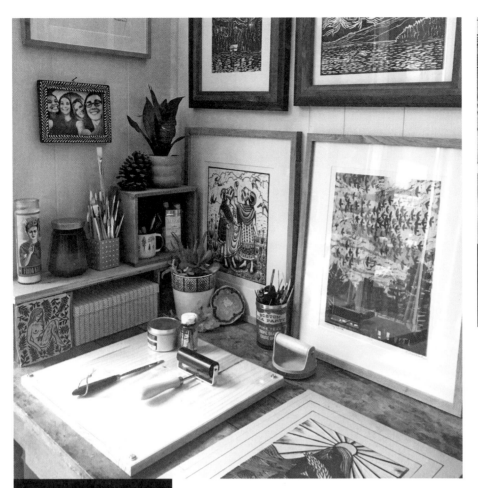

A second station, ready for printing

Inks, brayers, and other tools organized on a shelf above my worktable

When I'm not pulling by hand I use my Richeson Medium Etching Press. Though expensive and bulky, pulling prints with a press takes a lot of the physical gruntwork for you.

TIGHTROPE DRYING RACK

Tools and Materials

Ruler

Pencil

Drill

3/4" (2 cm) Phillips head screwdriver bit

1/8" (3 mm) drill bit

Two 1/2" (1.3 cm) floor flanges

Two 1/2" (1.3 cm) nipples

3/4" (2 cm) wood screws, Phillips head

Birch plywood board, 11 1/2" x 28" (29 x 73.5 cm)

Two 16" (40.5 cm) long pieces of 1/2" (1.3 cm) wide copper pipe

32" (81.5 cm) of heavy-duty picture hanging wire

15 small bulldog clips

Steel wool

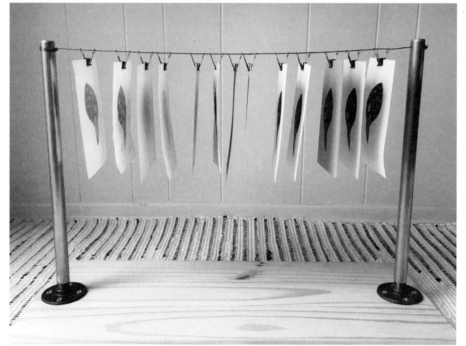

One of the most challenging aspects of working in a small space is finding a convenient place to store prints as they dry. This tabletop drying rack is a cheap alternative to specialty racks. It takes under an hour to build and requires no special skills or equipment. Have your board and copper pipes cut to size at your local hardware store. Be sure to sand off any rough edges before you begin, and remember to observe basic studio safety procedures.

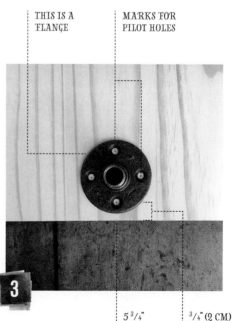

THIS IS A FLANGE

MARKS FOR PILOT HOLES

3

5 3/4" (14.5 CM) CENTER MARK

3/4" (2 CM) IN FROM THE EDGE

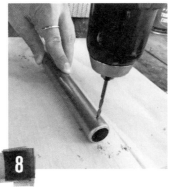

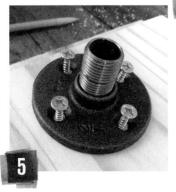

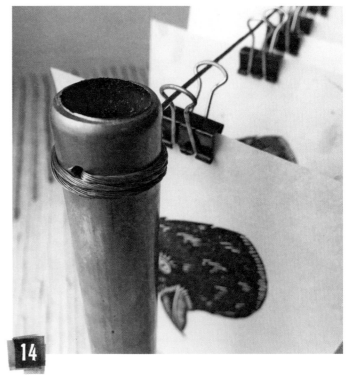

MAKE IT!

1 Make a center mark at the end of your board 5$^3/_4$" (14.5 cm) along the shortest end.

2 Come in $^3/_4$" (2 cm) from the center mark on the edge and make another mark. Repeat on the other end of the board.

3 Lay one of your floor flanges on the board as shown, centering one of the holes over your $^3/_4$" (2 cm) mark. Make marks in the remaining three holes.

4 Remove the flange. Use each of the marks to drill pilot holes with your drill and $^1/_8$" (3 mm) drill bit. This will keep your board from splitting.

5 Replace the flange. Screw in place with four $^3/_4$" (2 cm) wood screws.

6 Repeat steps 3 to 5 on the other end of the board.

7 Insert $^1/_2$" (1.3 cm) nipple into each flange and screw in tightly.

8 Take one of the copper pipe pieces. Measure and make a mark $^1/_2$" (1.3 cm) from the end of the pipe. Holding the pipe steady with one hand, use your electric drill with a $^1/_8$" (3 mm) drill bit to perforate two holes in the end of the copper pipe. Clean off any rough bits with steel wool.

9 Repeat step 8 with the second piece of pipe.

10 Take one of the copper pipes and attach the end without the hole onto the nipple set inside the flange. This may take a little bit of elbow grease and/or vise grips if you have them. Make sure that, as you screw it in, the two holes going through the top of the pipe are parallel with the grain of the board.

11 If you mark up or marr the pipe as you install them, a quick rub with steel wool will tidy them right back up.

12 Take your length of wire and thread it through one of the pipes. Tie a knot on the outside, trimming any excess wire (can be done with scissors or wire cutters).

13 Thread 15 small bulldog clips onto the wire.

14 Thread the other end of the wire through the opposite pipe, pull gently until taut, and then wrap the excess wire around the pipe, twisting the wire to secure in place.

15 Install your finished drying rack in your studio space and proceed to fill it with gorgeous, handmade prints!

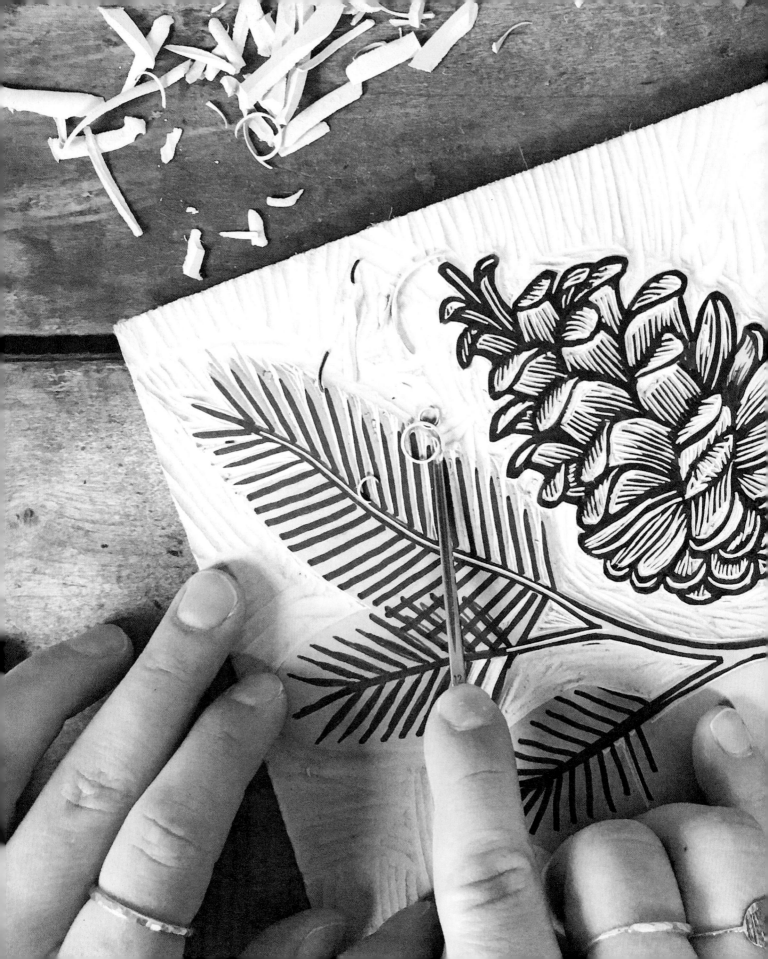

CHAPTER 2

ESSENTIAL TECHNIQUES

Though there are detailed directions for every project in this book, there are some essential practices that need tackling first. This chapter includes a refresher on some of the basic tenets of good design to help you plan your original compositions, and details different approaches to transferring images onto the carving block. You'll also find tips on carving techniques, the primary steps for pulling a print, and instructions about how to register (or line up) a multicolored print.

DESIGN ESSENTIALS

A good design is the foundation of a successful print. The elements and principles of design are a framework for helping us create, understand, appreciate, talk about, and critique art. They also make you sound smart at fancy parties! I like to think of design elements as my visual vocabulary. Here are a few key elements and principles of design brought to you by some of the best works from relief printmaking's history.

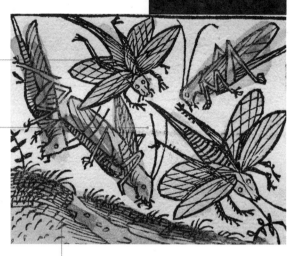

Positive space is the area taken up by an object/subject.

Negative space is the area around the object/subject.

Color adds life, vibrancy, and depth.

The artist achieves **texture**—the implied physical roughness or smoothness of an object—in the foreground by making a variety of marks that suggest grass.

A clear foreground, middle ground, and background are established, defining the **space**—the area in, around, or between objects in a composition.

The directional **lines** in the soil draw the viewer's eye, sweeping upward and into the scene.

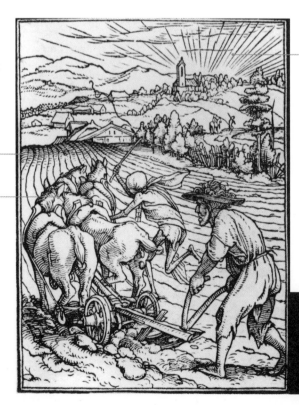

Converging lines on the horizon give the illusion of **depth** (the apparent distance from near to far).

The figures at the bottom of the picture plane are much larger in **scale** (size) than the buildings in the background, making them appear closer to the viewer.

The hatch marks within the forms add **value**, or the range of apparent lightness/darkness within the image. This is essential to making something two-dimensional appear three-dimensional.

Death and the Ploughman, Hans Lutzelburger, 1538

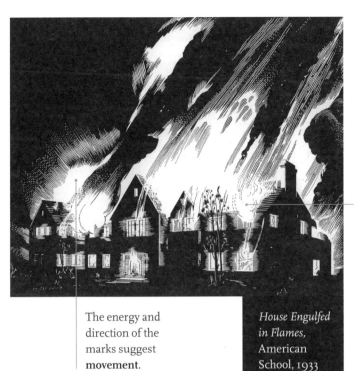

The subject of the image invites curiosity. Who lives there? What caused the fire? **Narrative** imagery (images that tell a story) at its finest!

A strong sense of **contrast** is created by using a limited range value—the white of the fire is shocking and bold against the dark house. This dramatic light helps to establish the **mood**, or overall feeling, of the composition.

The energy and direction of the marks suggest **movement**.

House Engulfed in Flames, American School, 1933

The central figure acts as a clear division of space, creating **balance** within the scene—the dark figures on the left contrasting evenly with the light dust cloud on the right.

The same pattern found multiple times within the image helps to **unify** the image, tying it together, which is when the composition as a whole feels complete and harmonious.

The artist employs a variety of line **weights** (weight = a line's thickness) to make the illusion of a cloud of dust the viewer can just barely see through.

A **pattern** is created by repeating shapes.

The Gale, Felix Edouard Vallotton, 1894

TRANSFER METHODS

Ask a group of printmakers about their favorite transfer technique and you'll get a wide variety of answers. The following four methods are those that I've found the most reliable, with the most consistent results. A solid transfer makes carving a much more enjoyable experience and gives you a clear roadmap to plan your cuts.

Drawing Rub

One of the quickest ways to transfer an original graphite drawing requires only some elbow grease! This method calls for a pencil drawing, tape, and a burnishing tool (a fat permanent marker works great).

1 Make a drawing with a soft graphite pencil on thin sketchbook or printer paper. Trim away excess paper with scissors.

2 Flip the drawing over, graphite side down onto your linoleum block, and tape it firmly into place. Take a spoon or butt of a marker and vigorously rub the back of the drawing, taking care not to let the paper slip.

Tracing Paper

I like this method because it allows you to make changes to the drawing as you transfer it to the block. All you need is a pencil, your original image, tape, and a piece of tracing paper cut down to size.

1 Place the tracing paper over your drawing and trace the lines. Make any necessary changes to the drawing as you trace.

2 Flip the tracing paper over, then tape it into place on the linoleum block. Go over the back of the drawing with a pencil. Use medium pressure, as it's easy to rip through the thin tracing paper.

Blender Pen

This method requires a photocopied image (use toner as opposed to ink—this method will not work with an inkjet print), a blender pen such as the Chartpak AD Marker Colorless Blender, tape, and a burnishing tool. Beware as some blender pens can have a very strong smell, so work in a well-ventilated area.

1 Flip the photocopy, image side down, and tape it firmly into place on the linoleum, keeping the image as flat against the linoleum as possible. Any waves in the paper could potentially cause the image to bleed.

2 Saturate the back of the copy with a blender pen, which will make the paper transparent. Be careful not to oversaturate the paper otherwise the toner will bleed and run.

3 Burnish the back of the paper with a firm tool until it is visibly dry. Allow it to sit for 5 minutes before peeling off the paper.

TIP: If the image is large, work in sections: go over a small area with the blender pen and then burnish. Move to the next small area and repeat until you've hit all areas of your composition.

Glue and Inkjet/Photocopy

This is a great method to use if you have a lot of intricate linework or a larger image with a lot of visual information. There are a few different material options for this transfer technique, but each yields crisp results. In my own explorations, I found that matte-finish Mod Podge with an inkjet print is a good combination, as well as Mod Podge Photo Transfer Medium with a photocopy. A cheap alternative to Mod Podge is clear-drying wood glue cut with a little bit of water. You'll also need a glue brush and a water-soaked rag. No matter what combination of paper/ink/glue you choose, the process is the same.

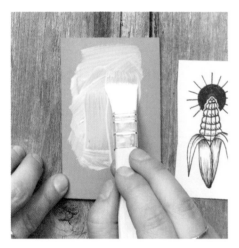

1 Brush a liberal amount of glue onto the surface of the linoleum, smoothing out any ridges made by brush bristles and avoiding globs.

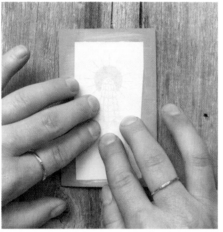

2 Flip the printed image over and place it on the wet glue, smoothing out any air bubbles. The idea is to ensure that each area of the source image comes into contact with the linoleum. For best results, allow to dry for 12 hours.

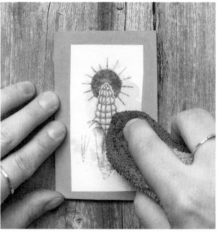

3 Take a wet rag and blot the back of the drawing. This will make the paper translucent. Let it sit for one or two minutes.

4 Use your finger to gently rub away the paper, revealing the drawing.

CARVING TECHNIQUES

I f thoughtful design is the foundation of a great print, then the carving technique is the frame, further supporting the overall piece.

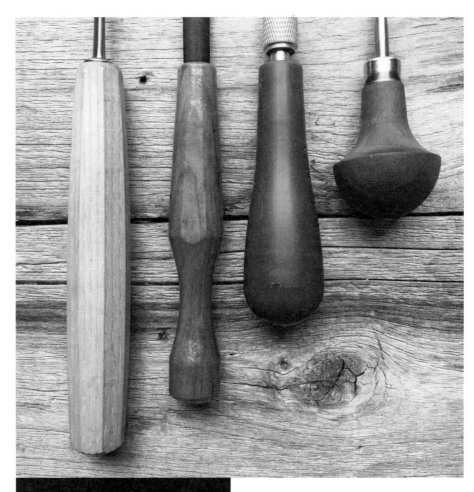

A lineup of tool handles

Grip

The shape and size of a carving tool's handle determines how you can hold the tool. There are many different styles of handles out there—some tools have a mushroom-shaped handle that fits comfortably into the palm of your hand, while others have larger, cylindrical handles that accommodate longer blades. Shorter blades give you a smaller range of motion and keep your hands closer to the cutting edge, both of which are good for detail work. Longer tools clear more material faster and are great for working on larger pieces. Hold the tool in whatever way feels most natural, but generally it's best to direct the blade away from your body to prevent accidentally stabbing yourself. These tools are sharp and can do a lot of damage if you're not careful, so always be conscious of your hand placement.

Carving with a full-size veiner, using my other hand to stabilize the blade

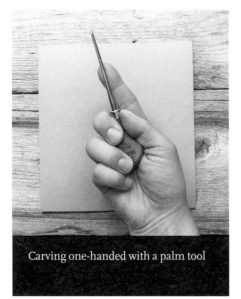
Carving one-handed with a palm tool

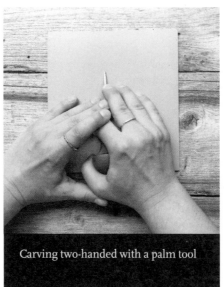
Carving two-handed with a palm tool

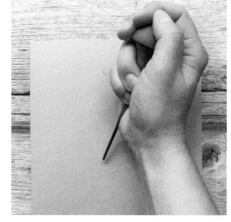

Sometimes I like to use a backward grip in highly detailed areas, as it allows me maximum control. But keep in mind that it's best practice to direct the blade away from the body. You can use a leather arm guard (like the kind used by archers) or a Kevlar sleeve to protect your carving arm from any possible slips of the blade.

Depth

In addition to the size and shape of your tool, the angle at which you hold it determines the depth of your cuts.

Holding the tool at a low angle, tip the blade down slightly to allow it to bite into the linoleum. The blade should glide smoothly.

Holding the tool at too low an angle will cause the blade to glance off the surface.

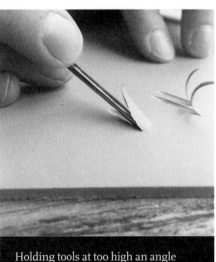

Holding tools at too high an angle will cause the top edges of the blade to dip fully under the linoleum's surface, resulting in tears.

TIP: To avoid background noise in your final print, consider depth when clearing out any negative space in your design. Carve these areas deeply, nearly to the hessian backing. If working with unmounted linoleum, the negative space can be trimmed away with scissors.

Channeling

One of the easiest ways to preserve delicate linework in your design is to carve channels around the form's outline and then clear out the space. These channels create a physical barrier that stops the blade.

Using a tool such as a bench hook will help to stabilize your block as you carve, allowing you to push against it with strength.
If you find it at all difficult to cut through the linoleum and you're wiggling the blade back and forth, it's probably time to sharpen your tools! (See Tools and Tool Care on page 14.) Some artists also find it helpful to heat the linoleum slightly before carving to soften it. You can use an iron on a low setting with a towel, but I find that sitting on my block like a hen works just as well.

PRINTING TECHNIQUES

These basic steps for making a relief print will stay the same for each project, with only minor variations.

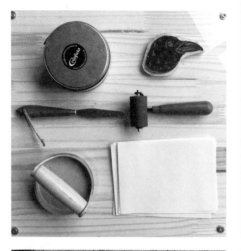

Your Basic Print Kit

Carved block, dusted to remove any fine and clingy linoleum cuttings

Paper cut or torn to size (your choice unless the project dictates otherwise)

Ink (I'll be using Caligo Safe Wash Relief Inks for the projects in this book)

Palette knife

Rubber brayer, sized appropriately for your block

Baren

Inking plate

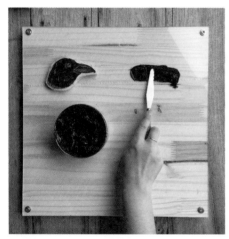

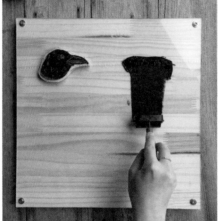

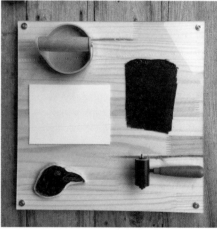

1 Using the palette knife, apply a small dollop of ink onto your inking plate. (If you're using ink from a tin rather than a tube, be sure to scrape the ink from the top instead of deeply gouging into the ink. This protects the ink from excess air exposure, which will cause it to get gummy and dry up.) Work the ink back and forth for a few minutes to warm it up, taking care not to spread it out any wider than the width of the brayer.

2 Touch the brayer to the ink and roll it back toward you, lifting the brayer and repeating a few times until the ink spreads consistently on the inking plate.

3 Examine the rolled ink. If you spot any ink "boogers," or dried bits of ink, you can pick them out easily with a scrap strip of mat board.

4 With the brayer, roll ink onto the block. Keep the roller parallel with the block as you apply the ink. Pull the brayer across the block in multiple directions, ensuring an even coating of ink. Take care to hit the edges of the block, which are easy to miss. Hold the block up to the light, tilting it and inspecting it to see that each area of the block is wet. Be careful not to swing too far in the other direction and overink the block, which would cause ink to bleed into the finer details.

5 If any ink has hit areas of negative space on your block, or anywhere else you didn't want your ink to go, you can wipe the area with a paper towel to avoid noise in your print.

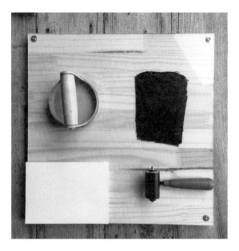 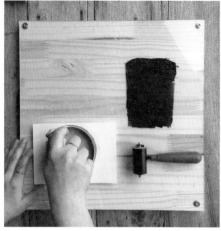

6 Apply paper on top of the block, taking care to lay it down once and not move it again.

7 Lightly hold the paper in place with one hand, and with the other, tightly grip your baren and press down on the block, moving in small circles with firm pressure.

8 Gently peel the paper off the block and place on your drying rack or on a flat surface.

Noise:
Extra marks on a print caused by ink hitting previously carved areas of the block. Noise can be intentional or unintentional.

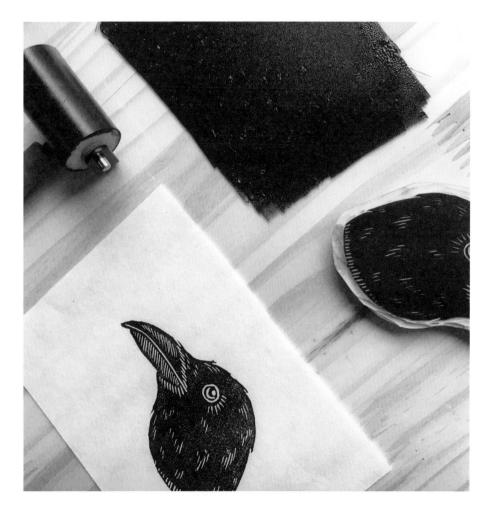

Ink Application

The application of ink can be a fickle process with many variables, starting with your brayer. I have artist friends who use exclusively hard rubber and some (like me!) who swear by soft rubber. The benefit of hard rubber is that it's great for applying thin layers of ink to delicate, detailed areas of the block, but I find that it's tough to get an even coating. The benefit of soft rubber is that the ink is applied evenly without much effort, but sometimes these brayers can deposit too much ink into shallow channels, causing details to bleed out upon printing.

DIRECTION OF APPLICATION

As you pull the brayer across the block, move in multiple directions—up and down as well as left to right—to ensure that each area of the block receives ink. If your brayer is not quite wide enough to stretch across the whole block, stagger your passes so the ink layers evenly. Beware of any large areas of negative space, as the brayer may hit it and deposit ink accidentally, causing noise or accidental marks in the final print. It's up to the artist to decide what is or is not an acceptable amount of noise.

PRESSURE OF APPLICATION

The pressure used when rolling the brayer across the block depends on a couple factors: consistency of the brayer and consistency of the block. If your brayer is soft, you'll barely need to assist gravity because pushing too hard will cause the soft rubber of the brayer to push into the channels you've carved, depositing ink where you don't want it. You may need to lean into the brayer slightly if it's hard rubber, as it needs a bit more pressure to evenly deposit ink.

If printing with a soft rubber block instead of dense linoleum, a much lighter touch is required. Push too hard and the block will squish, allowing ink into shallow channels, causing detail loss in the final print.

Using too much ink can also cause the ink to squish up over the edge of your brayer. This can can cause unsightly lines and globs of ink to appear in the final print. Always make sure that your brayer is properly cleaned after each printing session to avoid dried ink buildups.

Goldilocks and the Three Prints

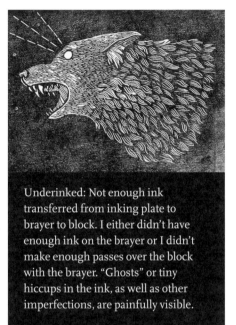

Underinked: Not enough ink transferred from inking plate to brayer to block. I either didn't have enough ink on the brayer or I didn't make enough passes over the block with the brayer. "Ghosts" or tiny hiccups in the ink, as well as other imperfections, are painfully visible.

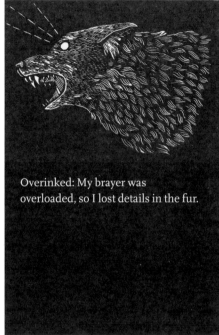

Overinked: My brayer was overloaded, so I lost details in the fur.

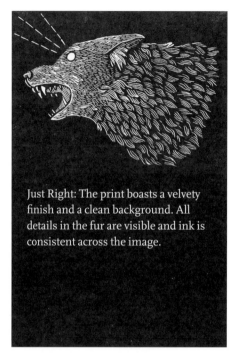

Just Right: The print boasts a velvety finish and a clean background. All details in the fur are visible and ink is consistent across the image.

TIP: Peeling a fresh print from a block too quickly can cause the paper to skip or shift, resulting in fuzzy lines. Go slowly and gently, and don't let the paper shift.

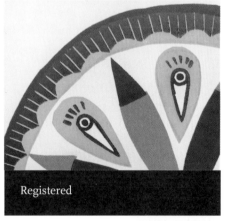

Registered

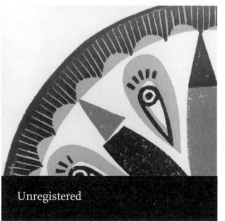

Unregistered

Registration

Registration is a system used by printmakers to ensure that the block and paper are both in the same position for each print. This is most important when you are printing with multiple colors layered on top of one another—being off by even a millimeter can have disastrous effects on a detailed composition.

Additionally, the straighter the block is on the paper, the more professional the print's appearance will be. A crooked print can be saved by some clever framing, but it's best to avoid such trouble if you can.

On the following pages are three different types of registration devices, or printing jigs. Each of these is used at least once for the projects in this book, but will also help you keep printing straight long after you've closed these pages.

PROJECT:
BOX GRID

Tools and Materials

Scrap piece of 11" x 14" (28 x 35.5 cm) board
Ruler
Permanent marker

This is the simplest type of registration device, and the one I use most often. It works best with unmounted blocks or printing surfaces with a lower profile. I made an easy device from a scrap piece of hard composite wood.

MAKE IT!

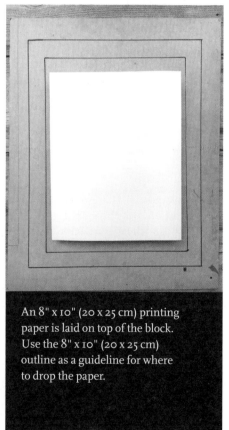

4" x 6" (10 x 15 cm)
5" x 7" (13 x 18 cm)
8" x 10" (20 x 25 cm)
9" x 12" (23 x 30.5 cm)
11" x 14" (28 x 35.5 cm)

TIP: This device can also be made on the fly with a larger scrap piece of paper—just trace your printing paper and then trace your block within.

1 With a pencil and a ruler, trace outlines of the standard sizes of papers and blocks that you use the most. Go over the lines with a permanent marker. Standard US sizes are 4" x 6" (10 x 15 cm), 5" x 7" (13 x 18 cm), 8" x 10" (20 x 25 cm), 9" x 12" (23 x 30.5 cm), and 11" x 14" (28 x 35.5 cm).

2 To register the block, simply set it within the outline of its corresponding size. A 5" x 7" (13 x 18 cm) block is placed in 5" x 7" (13 x 18 cm) space.

An 8" x 10" (20 x 25 cm) printing paper is laid on top of the block. Use the 8" x 10" (20 x 25 cm) outline as a guideline for where to drop the paper.

PROJECT:
HINGED WINDOW

Tools and Materials

Two precut 11" x 14" (28 x 35.5 cm) mats with an 8" x 10" (20 x 25 cm) window

One 11" x 14" (28 x 35.5 cm) or larger board

Tape

Ruler

Pencil

With the hinged window, the block sits snugly within the slightly raised border of the base window, and printing paper is taped to the top window. The printing paper is aligned with the upper guideline. When the block is inked and the top window is closed, the paper comes into contact with the block.

MAKE IT!

1 Glue one of the precut mats flat to the 11" x 14" (28 x 35.5 cm) board, keeping the edges of the mat and the board flush together. Weight the mat while the glue dries to ensure a full bond. This creates a shallow space that will hold your block in place as you print.

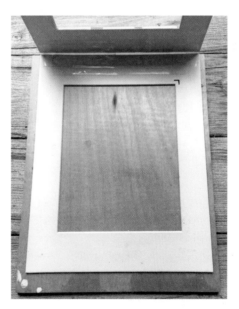

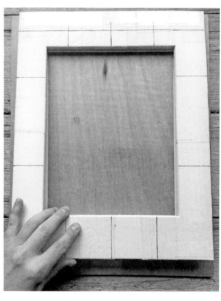

2 Place the other mat directly on top of the attached mat. Firmly tape the two mats together along one of the short ends. The tape creates a hinge and allows the top mat to swing open.

3 Place registration marks on the top mat. Draw a dark line along the top, parallel to the hinged edge. This will be the guideline to which you will match the top of your printing paper.

4 Draw marks all around the mat—the more marks you make, the more precise your registration will be. For a more detailed look at using this device, see Multi-Block Hex Sign project, page 56.

PROJECT:
PIN AND TAB

Tools and Materials

Scrap piece of board

One thin, narrow strip of wood or cardboard

Tape

Glue

Ruler

Pencil

Pins and tabs

This method requires the use of Ternes-Burton registration pins and stripping tabs, which are readily available directly from the company's website or through most well-stocked online art supply retailers. They're cheap and wildly effective—I would consider this the most precise registration technique of the three. Stripping tabs are attached to the paper and the pins are attached to the jig. The tabs fit into the pins, holding the paper firmly in place.

1 Take a scrap piece of board (it helps if it's squared, with straight edges and 90-degree angles) and glue the thin strip to it, along the top. Allow it to fully bond. The bottom of edge of this strip will act as a bumper to align the top edge of your printing paper.

MAKE IT!

2 Place the registration pins on the strip, lining them up with the bottom edge of the strip. Tape them firmly in place. (I use tape for this device so that I can move elements around when I'm working on differently sized blocks.)

3 The pins hold the paper in place but we need something to hold the block in place, too. Place two strips of mat/card/chip board together like an L to form a 90-degree angle. Decide where you want to place your block and firmly tape the L to the board at your block's lower left-hand corner. A more detailed look at using this device can be found in the Reduction Cut Sunflower project, page 64.

Cleaning Up After Printing

Proper cleanup preserves the life of your tools, the integrity of your prints, and will help you keep your sanity in the studio. Follow this cleanup process after every print run. (Instructions intended for the oil-based, washable inks used throughout this book.)

Hang all wet prints on the drying rack.

Clean the brayer: Remove excess ink by rolling the brayer on an old phone book or magazine. Discard and repeat until nothing comes off on the paper. Wash in the sink with soap and water.

Clean the inking plate: Scrape away excess ink with an ink scraper, palette knife, or mat board strip. If the ink is uncorrupted (meaning nothing else has been mixed into it), excess can be placed back in its original container. If the ink is corrupted or you can't get it back into the container (for example, if it came from a tube), discard. Once ink is scraped up, the quickest and most efficient way to wipe down the plate is with a disinfectant wipe. Alternatively, you can use vegetable oil and paper towels.

Wipe excess ink from palette knives and clean thoroughly with vegetable oil and a paper towel or a disinfectant wipe.

Clean the block: Blot away excess ink by pressing the block with newsprint or scrap paper. Wipe with vegetable oil or a disinfectant wipe. Though the inks used throughout the book clean up with soap and water, I try to always keep my blocks dry. If the hessian backing of unmounted linoleum gets too wet, it can cause the linoleum to curl.

Replace all caps and lids tightly, and store any inks in clear containers away from light.

Wash your hands thoroughly with pumice soap such as Permatex Fast Orange (soaps like this are easily found at hardware or automotive stores. Also it lasts forever—I've been using the same 64 oz container for over two years). Scrub under your fingernails with a brush.

Editions

An edition is a set of identical prints. Each print of the edition is considered an original, and is numbered, signed, and dated by the artist along the bottom of the print. The majority of artists choose to sign in pencil. The artist's signature is traditionally located in the lower right-hand corner and the title of the print is in the center. In the lower left-hand corner you'll find the edition number:

NUMBERING

If you make an edition of 20, you will number each print as 1/20, 2/20, 3/20, and so on. Though each print should be as close to identical as possible, generally the cleanest/best prints in the edition will be numbered lower. So the first print in an edition of 100 (1/100) will be better quality/more valuable than 96/100.

There are other ways to identify a print. Sometimes at the bottom of a print you'll see A/P or AP, which stands for Artist Proof. The first few pulls of a block are known as the test prints or proofs, and are not considered a part of the edition. This is the time to test out how much ink you need to apply, adjust the pressure of your baren or press, and make any final cuts into the block.

CHAPTER 3

THE BASICS

The projects in this chapter will take you on a tour of foundational concepts of the relief printing process. Here you'll learn how to:

- Achieve a variety of textures through the manipulation of your tools;
- Make a three-color print with three separate blocks;
- Make a three-color print with a single block;
- Manipulate lines to render an object in three dimensions;
- Use collage and hand painting to embellish a print;
- Use text to print your own tiny book

In completing these projects, you'll learn to do a bit of inverted thinking. Remember that relief printing is in essence a **reductive** or **subtractive** process—artists *remove* linoleum from the block to reveal the design (in contrast, hand building with clay is an **additive** process—where elements are gradually *added* to the form). Learning to think subtractively will help you plan better prints and execute more nuanced results.

PROJECT:
TEXTURE QUILT BLOCK

Tools and Materials

9" x 9" (23 x 23 cm) unmounted linoleum

Pencil

Ruler

Permanent marker

Carving tools

Inking plate

Palette knife

Brayer

12" x 12" (30.5 x 30.5 cm) printing paper

Baren

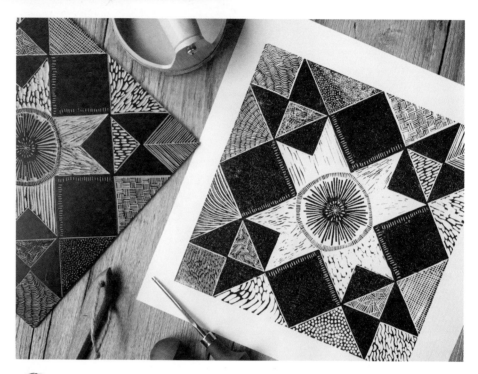

The best way to get to know your carving tools and the magic of wielding them is to dive right in! This classic moonlight star quilt pattern provides the perfect visual structure for experimenting with mark making, textures, and values all in the same project.

For this project, you will be attempting to use as many of your carving tools as possible to make as many different textures and values as possible.

This will involve experimenting with:
- The shapes made by each of your tools or blades
- The depth of your blades in the linoleum
- The length of strokes
- The direction of your strokes
- The spacing of your marks
- Whether cuts intersect or are parallel

We won't need to use any transfer techniques for this texture exploration, as we will be drawing directly onto the block. I recommend drawing the full design in pencil first, then going over your drawing with a permanent marker, so you can edit any mistakes.

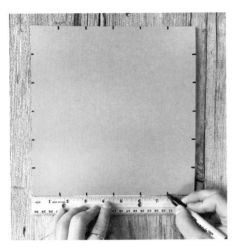

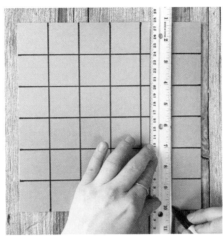

1 Begin by making a 1½" (4 cm) grid on the linoleum block. Using your ruler for precise measurements, make tick marks at 1½" (4 cm) increments around the perimeter of the block.

2 Line up the marks on opposite edges with your ruler, using it as a guide to draw perpendicular lines across the block. You should end up with 36 squares measuring 1½" (4 cm) each.

3 Locate the middle mark along each edge. Connect the four middle marks with the ruler to make a diamond shape.

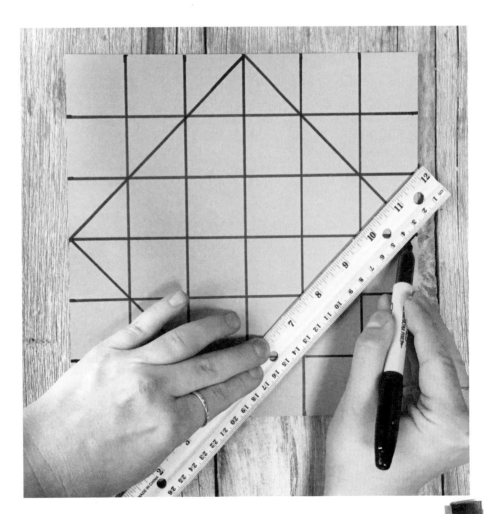

4 Using these sequential images as a guide, complete drawing the moonlight star pattern on your grid. Color the given spaces black with the permanent marker. This will help you remember where to carve.

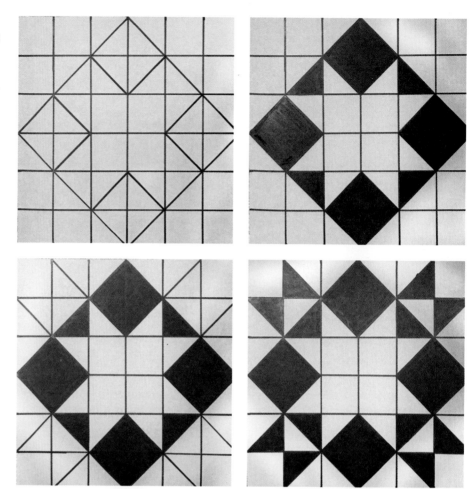

5 In order to visually anchor the design, you will not carve in the areas filled in with black. The goal is to fill the blank areas of the design with as many different marks, lines, and textures as possible, using as many of your tools as possible. Take a moment to consider all the ways you might manipulate your tools to create different effects.

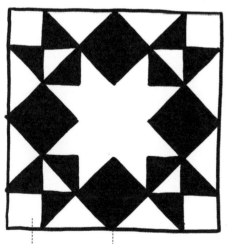

CARVE IN BLANK AREAS

LEAVE BLACK AREAS ALONE

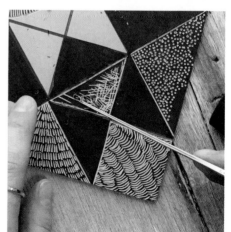

6 Using a narrow V tool, carve around the inner border of each blank shape. This will help you keep your marks where you want them. Then fill in that same shape with a permanent marker. This will make it easier to see your marks as you carve.

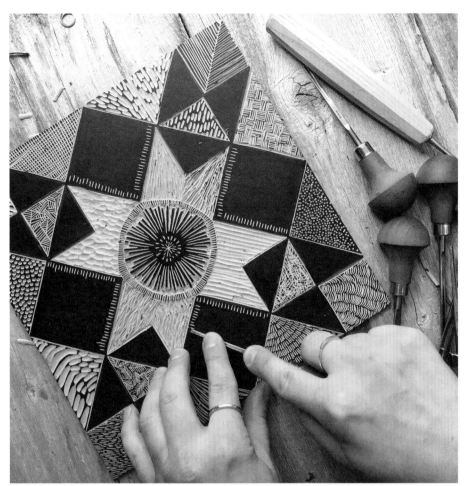

7 Carve until all blank areas have been filled with texture. Treat the star in the center as a free space where you can create any pattern, texture, or design you like to make your print truly your own. If you decide that all that work simply wasn't enough, you can embellish the black areas as well.

8 Use a draftsman duster to brush off all cuttings. A thorough job of this will mean a cleaner print down the road.

9 Shave a quarter-sized dollop of ink from your tin, and warm it up by spreading it on your inking plate with a palette knife.

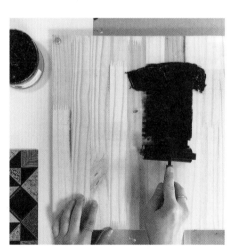

10 Using the largest brayer you have to accomodate the block, roll out the ink on the inking plate until you achieve a nice even layer on your brayer.

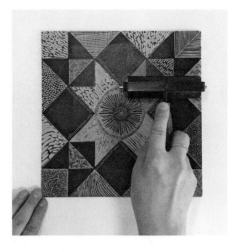

11 Apply ink to your block by making several passes with the brayer, returning to the inkwell on your platen as needed. Take care not to overink and fill in any fine textures you may have carved. Pay close attention to the edges of the block, which can be easy to miss.

12 Place the paper of your choice (Blick Masterprinter Paper pictured here) over the block, securing it in place by lightly pressing down with your hand. Grip the handle of your baren tightly and rub the back of the paper, applying even pressure across the block. You may wish to further burnish the back of your paper with a wooden spoon to achieve more consistent blacks in the uncarved areas.

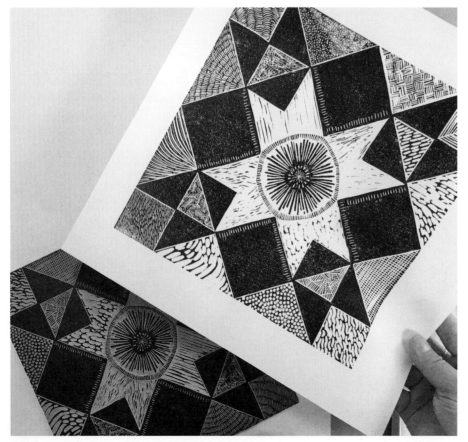

13 Carefully peel off the paper, and place in a safe area to dry.

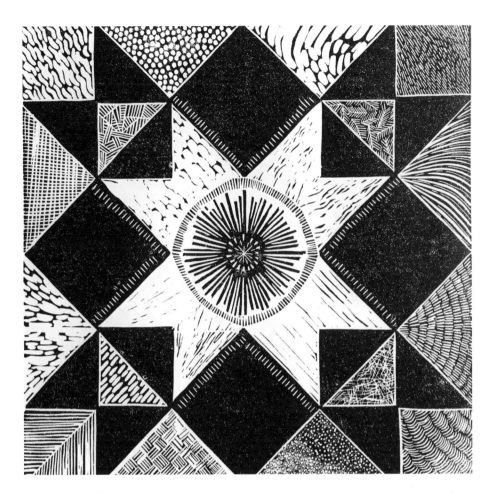

TYPES OF LINES
TO CONSIDER:

Straight lines
Curved lines
Swirling lines
Directional lines
Long lines
Short lines
Dots
Scratches
Hairy lines
Overlapping lines
Expressive lines
Lyrical lines
Parallel lines
Feathery lines
Jagged lines
Broken lines
Continuous lines
Woven lines
Marks far apart
Marks close together
Organized lines
Random lines
Wide lines
Thin lines
Unintentional lines

Mark Map: To recreate the marks I've made in the completed example above, refer to the map (right) to find out which tools were used to make what marks.

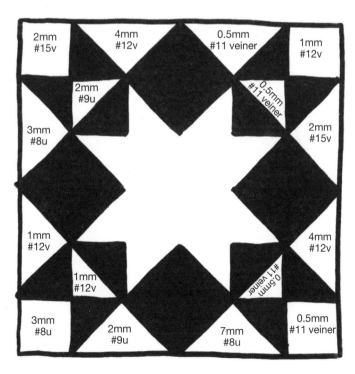

MULTI-BLOCK HEX SIGN

Tools and Materials

Three pieces of 6" x 6" (15 x 15 cm) unmounted linoleum	At least two pieces of tracing paper
	Drawing paper
Three pieces of 7 $^1/_2$" x 9 $^1/_2$" (19 x 24 cm) firm chipboard, or mat board	Compass
	Carving tools
	Three color inks
Wood glue	Inking plate
Hinged registration device	Palette knife
	Brayer(s)
Pencil	9" x 12" (23 x 30.5 cm) printing paper
Ruler	Baren
Permanent markers in various colors	Masking/washi tape

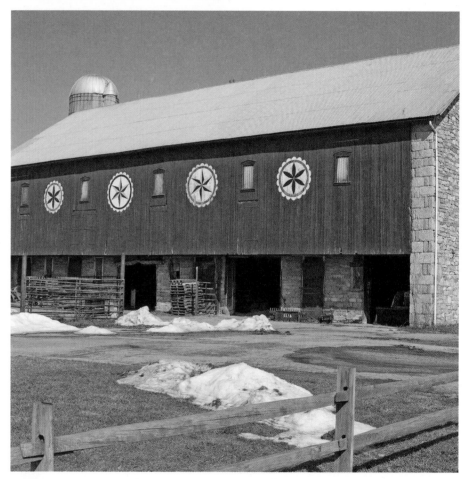

Hex signs—also referred to as barn stars, but not to be confused with barn quilts—are a ubiquitous part of the rural Pennsylvania landscape, adorning the facades and gables of barns. These striking, perfectly balanced circular designs are part of a folk art tradition brought to the United States by the Pennsylvania Dutch, a group of German immigrants in the early 1700s. Employing either rotational symmetry or parallel (reflective) symmetry, contemporary hex signs often incorporate symbolic motifs: stars and rosettes for good luck, tulips for faith, wheat sheaves and rain drops for abundance, oak leaves for strength of character, and more.

For my hex sign, I used an eight-pointed rosette as the main element, adding in raindrops, a scalloped border, and watchful eyes. You can design your own, using symbols and colors that are meaningful or pleasing to you.

For this project, we will be using the **multi-block technique**, where the impressions from three separate blocks, each inked with a different color, will create a three-color print. Remember that you are welcome to experiment as you please with colors of your own choosing. Printing with multiple blocks can be a little bit tricky if it's your first time, but be patient with yourself and diligent with your measurements, and together we can pull something clean! When it comes to multi-block printing, planning is everything, starting with the design.

Key block:
In multi-block printing, the block that contains the primary part of the image, often printed in black

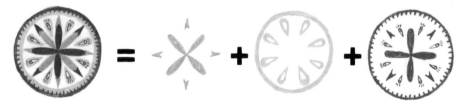

1 First let's get a bit of prep work out of the way: each piece of unmounted lino must be adhered to a piece of $7^{1}/_{2}$" x $9^{1}/_{2}$" (19 x 24 cm) board in order to work properly in the hinged registration device. I used chipboard, but you can use mat board or dense cardboard as well. Using a ruler, center your block on the chipboard (the more exact the measurements, the better), and glue it in place with wood glue. Place it under a heavy stack of books to ensure a full bond. Repeat with the remaining two blocks. Add a tab with masking tape at the bottom of each board to make it easier to remove from the device.

2 While you wait for your blocks to bond, plan your design. I usually begin with a simple line sketch, followed by a full-color sketch. Then I visually separate the colors so I can see how my blocks are supposed to look.

3 Now that you have your plan, make a clean, full-size line rendering of your design on drawing paper (we'll call this the master drawing). I suggest using a ruler and a compass in order to make drafting a perfect circle easier. Be sure this design will fit on your 6" x 6" (15 x 15 cm) blocks.

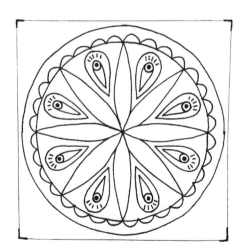

4 According to the plan, the blue block has the most visual information, so this block will be the key block, which will serve as a guideline for the other colors. Lay a sheet of tracing paper on your drawing, taping it in place if desired. Carefully trace only the blue parts of the design. Mark the top of the design so you know which way is up—when transferring rotational designs, things can get confusing!

5 Grab one of the mounted blocks. Place a mark on the board to signify the top. Transfer your traced image onto the block (see Transfer Methods on page 32). Lock the drawing in place with a permanent marker (you don't have to color in with the marker, you can just draw in the lines).

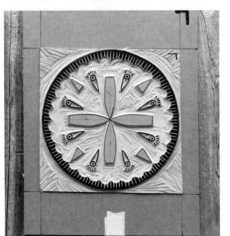

6 Carve out the negative space.

7 Now we will use the carved key block to transfer the design onto the remaining blocks. Grab the hinged registration device. Firmly tape a clean sheet of tracing paper to the window.

8 Open the window of the registration device and set the key block into the jig, ensuring that it fits snugly in place and does not move.

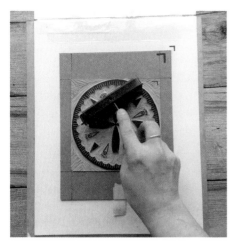

9 Roll out just a little bit of a light-colored ink and ink up the key block. (I used a dark blue ink, which stained the blocks; lighter inks are easier to remove.)

10 Close the window. Using a baren, gently press and rub the back of the tracing paper until you see the ink transferring. You may find that you need to use a spoon to extract fine details.

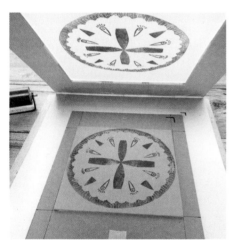

11 Now you will transfer the design from the first block onto the second block. Open the window and remove the key block. Replace it with the second mounted block, marking the top.

12 Close the window and rub the back of the tracing paper again, transferring the design back onto the block.

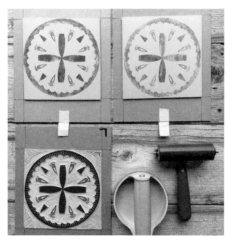

13 Open the window, remove the second block, and set it aside to dry. Repeat step 12 with the final block, marking the top. Set aside to dry. (I let them dry overnight.)

14 Clean excess ink off the key block and set it aside to dry. Remove the printed tracing paper from the window and discard.

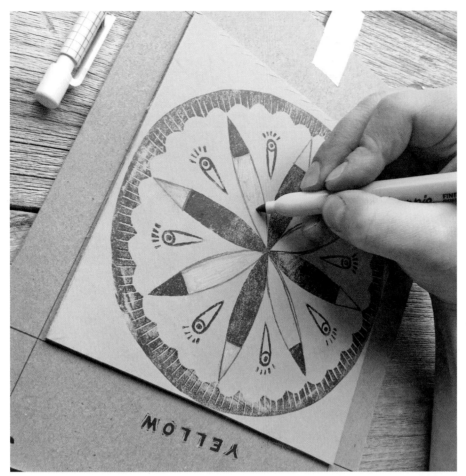

15 Take the now-dry second block. This will be the yellow block. Using the transferred image on the block as a guide, draw in the yellow elements freehand. Alternatively, you can return to your master drawing, trace the yellow elements, and then transfer them that way. You won't have to worry about cleaning the ink off of this block, because you'll be carving most of the already-inked bits away.

16 Carve away all the negative space—everything except what you want to print yellow. Set the carved block aside after labeling it.

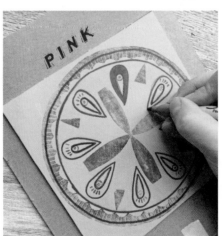

17 Take the final block and draw in all the pink elements.

18 Carve away all the negative space—everything except what you want to print pink. Label the block.

19 Take a clean sheet of printing paper and line it up using the guideline at the top of the closed window of the registration device. Tape it into place.

20 Using a sharp pencil, mark the top of the paper and then make registration marks around the perimeter, using the guidelines on the window. These lines will help you put your paper in the exact same place every time.

21 When printing with multiple colors, it's best practice to always start with the lightest color first, and then build up to darker colors last. Begin with the pink block. Open the window on the registration device and place it securely within the jig.

22 Mix your inks with a palette knife on your inking plate to get the color you want. To achieve the peachy-pink pictured here, I mixed Caligo Safe Wash Relief Inks in light orange, rubine red, and opaque white.

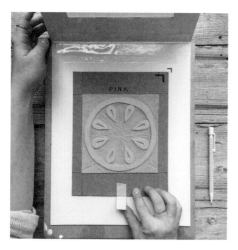

23 Roll out a small amount of pink ink and apply it to the block with your brayer. Clean up any stray ink with a cotton swab or rag.

24 Close the window. Carefully press the back of the paper with your baren, taking care not to press too hard, lest you tear the paper on a sharp carved edge.

25 You can lift the window to see whether your ink is transferring evenly onto the paper. If it's not, simply close the window and press again, increasing pressure with your baren or burnishing with a spoon. Once you've printed the pink block successfully, open the window and take it out of the jig.

26 Normally I wait 2 to 3 days between printing different layers of color to allow the ink to dry, but since the pink and yellow elements don't touch in this design, I can print them both in the same session. That means we can leave the paper in the window. Place the yellow block in the jig.

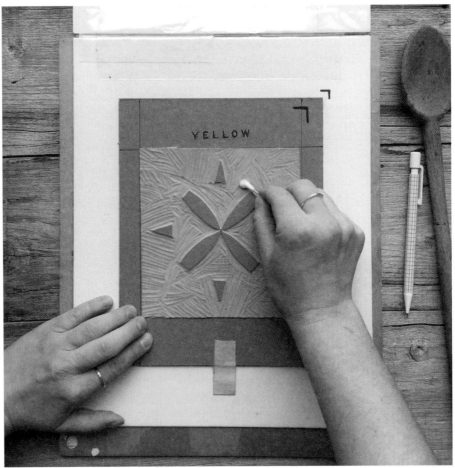

27 Roll out the ink and apply it to the yellow block with a clean brayer.

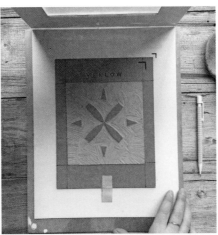

28 Close the window and press with your baren, printing the yellow block. Now you have both the pink and yellow blocks printed on the same sheet of paper.

29 If you were to print an edition of your own original design, you'd repeat steps 19 through 28 for as many prints as you like. If you are pulling just one print, you can leave the paper in the registration device to dry overnight. Clean up your workstation and tools, and save any excess ink in small, airtight containers.

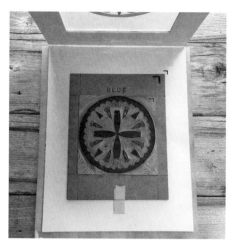

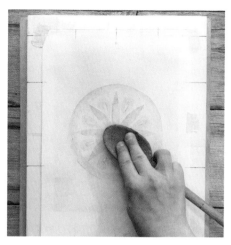

30 When the print has sufficiently dried (no longer tacky to the touch and your finger comes away clean) it's time to print the final layer—the key block! Mix the color you'd like to use with a palette knife on your inking plate. I used phthalo blue, black, and opaque white to achieve the smoky navy blue pictured here. Roll out the ink with a brayer and apply it to the block, cleaning up any stray ink.

31 Ensure that the paper is still lined up with the registration marks. Place the block in the jig and close the window.

32 Using a baren, press the back of the paper and print the key block, opening it to check that you've hit all areas of the design.

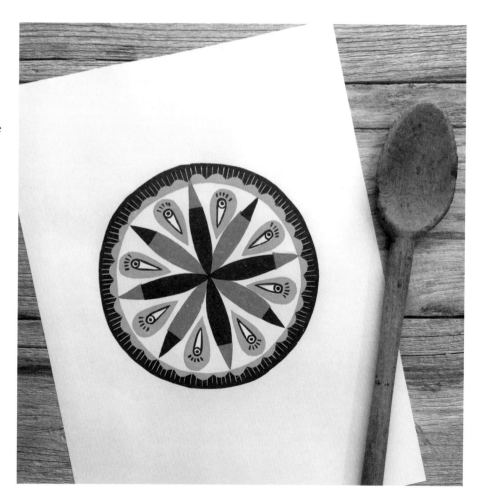

33 Congratulations! Now you have a tightly registered, three-color multi-block hex sign print!

PROJECT:
REDUCTION CUT SUNFLOWERS

Tools and Materials

4" x 8" (10 x 20 cm) unmounted linoleum

Pencil

Colored pencils

Ruler

Permanent marker

Tracing paper

Carving tools

Pin-and-tab registration device (see page 46)

Tabs

Washi/masking tape

Inking plate

Three colors of ink

Palette knife

Brayer

9" x 12" (23 x 30.5 cm) printing papers

Baren

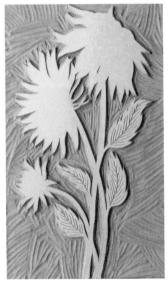

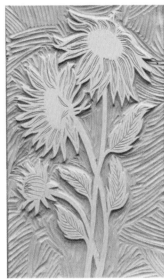

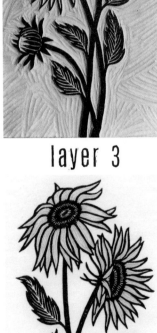

layer 1

layer 2

layer 3

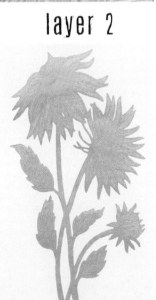

In this project, we explore the **reduction cut**—a method of color printing in which you use the same block over and over, carving more away with each new layer of color. Flowers have been an enduring subject for artists, and their wide range of colors and shapes make them great for study when it comes to reduction cuts.

1 Before we begin drafting the block, let's prepare our printing materials. First, we need to add a custom jig to the pin-and-tab registration device (see page 46). I knew that I wanted the block relatively centered within the printing paper, so with a pencil I drew two guidelines on the registration device to center the block vertically. Then I eyeballed it so the block would fall between the pins, thus centering the block horizontally.

2 Place a heavy object (I used a stone) on the block to keep it from scooting out of position. Take two strips of mat board, chipboard, or cardboard and position them perpendicular to one another to form a 90-degree angle. Tape these strips firmly into place at the bottom left-hand corner of the block.

3 Now that the jig is ready, the paper must be prepared. Cut or tear paper to 9" x 12" (23 x 30.5 cm). Take a sheet of paper and lay it on the registration device. Line up the top edge of the paper by placing it flush against the raised strip (the bit of board to which the tabs are taped). Once the paper is aligned, attach two tabs to the pins, which will then overlap the top edge of the paper. Tape the tabs into place. Repeat this process for the rest of the papers (as always, the edition size is up to you). These tabs will remain attached to your papers until you've printed the third and final color.

AN IMPORTANT NOTE ON TAPES

Test your tapes and how they adhere to your papers before you actually tape the tabs into place. The washi tape used in these photos pulled cleanly off the Blick printmaking papers, but tore the more fibrous kozo paper. Some printmakers prefer painter's tape, but I find that sometimes it loses its stickiness too quickly. You may need to do a little trial and error beforehand. It would be super sad to ruin a perfect print by accidentally tearing the paper when removing the tabs! (However if this does happen, you can use the print in one of the projects in Chapter 5: Waste Not.)

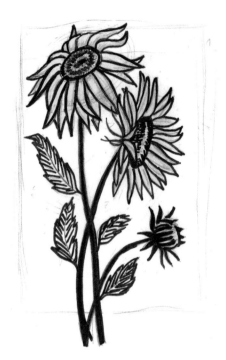

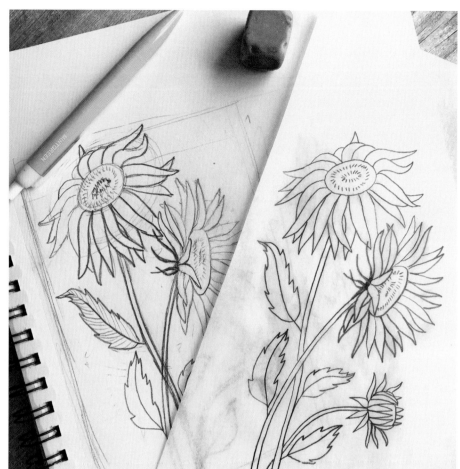

4 Sketch your design and then do a final line drawing. Use colored pencils to plan where you want your colors.

5 Tape a piece of tracing paper over your drawing and carefully trace the design with a sharp, soft graphite pencil.

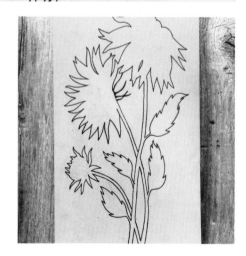

6 Flip the tracing paper onto the block and tape it in place. Trace only the outline of your design. Lock the drawing into place with a fine-point permanent marker.

7 Carve out the negative space. This will give your image a clean, blank background.

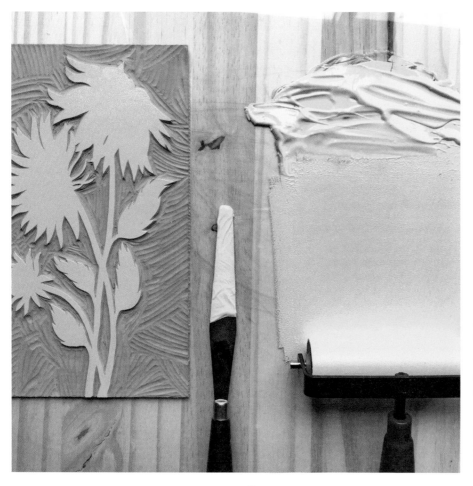

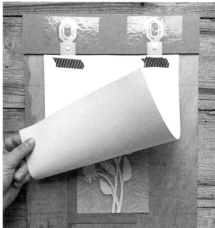

8 As always, we start with printing the lightest color first, in this case the yellow. (To make a happy, sunshiny yellow, I mixed Caligo SafeWash Relief inks in diarylide yellow and opaque white.) Mix and spread the ink with a palette knife on your inking plate.

9 Roll out the ink and apply it to your block. Take care to wipe off any wayward ink.

10 Set the block into the pin-and-tab registration device, making sure that it is firmly tucked into the corner of the jig.

11 Fit a tabbed piece of printing paper into the pins and carefully lay down the paper. Press firmly on the back of the paper with a baren, taking care to hit every area of the block.

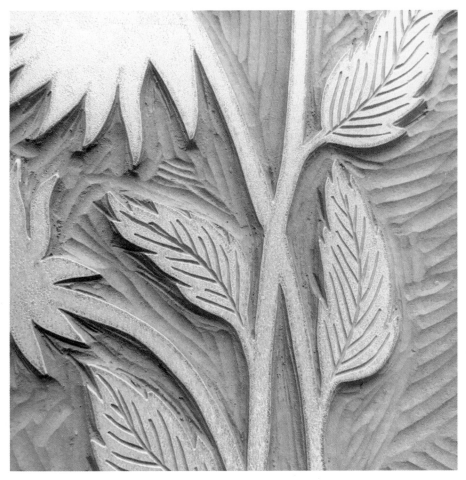

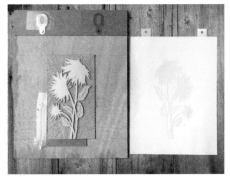

12 Peel up the paper to check that all areas of the block are transferring evenly. Use a firmer baren such as a spoon to coax out stubborn details. This is also a good time to recheck your design. (At this point, I realized that I wanted the veins in the leaves to read as white lines, so I went back and carved them.)

13 Set the print aside to dry and repeat steps 9–12 as often as your edition size calls for. Even when mixing in cobalt drier to speed up drying time, I still like to allow three days in between layers to ensure that the ink dries completely. Printing wet ink onto wet ink can cause a loss of detail and inconsistent, blotchy color.

14 Clean excess ink from the block by first blotting with scrap paper and then wiping the block down. Highly pigmented inks often stain the block, but as long as the block is thoroughly cleaned, these stains will not transfer.

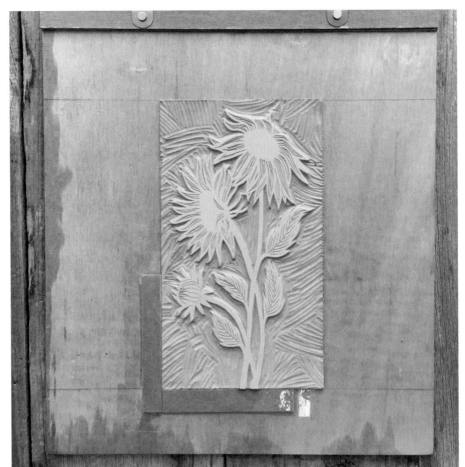

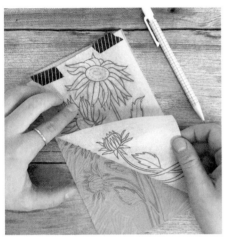

15 Using the traced image from step 5, line up the image with your carved block and transfer the details. Everything that you carve away now will remain yellow on the print. Carve out everything that you want to remain yellow. For this design, you will be mostly carving out the petals of the flowers.

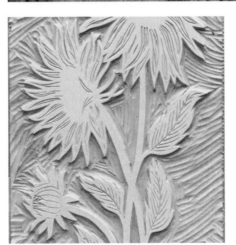

16 Now that you've carved the second pass, it's time to print orange (I used light orange, diarylide yellow, and opaque white to achieve this color). Roll out the ink, apply to the block, and place the block in the jig.

17 You will be printing directly on top of the previous, now-dry yellow layer. Print the orange block and repeat as per your edition size. Set the prints aside to dry.

18 Clean excess ink from the block by first blotting with scrap paper and then wiping the block down.

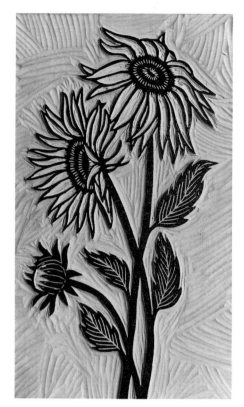

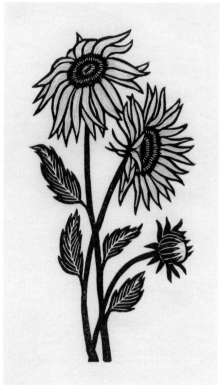

AN IMPORTANT NOTE ABOUT REDUCTION CUT PRINTS

With reduction prints you will only ever be able to do a single, limited-edition run. Because you use the same piece of substrate for each block, you essentially destroy the first block in order to make the second—and then destroy the second in order to make the third, and so on.

19 Time to carve for the third and final time. Cut away the portions of the block that you want to remain orange. Everything you leave on the block after this will print black. So for this design, carve out everything except the outline.

20 With the final pass carved, roll out the black ink and apply it to the block. You will be printing directly on top of previous, now-dry yellow and orange layers. Print the black block and repeat as per your edition size. Set aside to dry.

21 Clean your block, workspace, and tools.

22 When the final layer has completely dried, carefully peel the tape and tabs off your prints.

You can try printing on colored paper too!

ARTIST SPOTLIGHT:
DERRICK RILEY

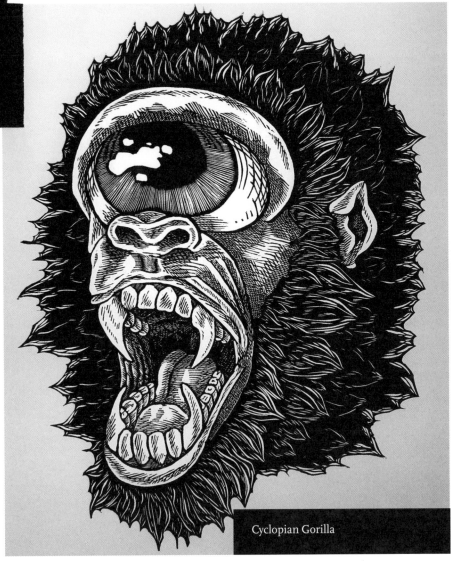

Cyclopian Gorilla

My life changed forever when, as a senior at the University of Kentucky, I took my very first printmaking class, beginning woodcut, with Derrick Riley. An MFA and member of the Kentucky Division of the famed Outlaw Printmakers, Riley has been operating his own press since 2005, churning out epic-scale narrative prints that celebrate the strangest of Kentucky folklore, randy robots, and curious creature mashups. He's known for his bold, graphic style and finely detailed renderings of form.

EH: How did you first become interested in printmaking?

DR: I was a drawing major as an undergrad, and a printmaking course was required for my degree. During the course, in 2000, there was a Joel Feldman retrospective at the university museum. The exhibition had these gigantic banner style black and white woodcuts of Aesop's Fables that were amazing. Until that time I had never realized that a print could be that large. After that I was hooked.

EH: What drew you to relief in particular?

DR: Several things initially drew me into relief printmaking. First of all, playing with knives all day is pretty awesome. And I was intrigued with how the visual power of a limited palette—and the stark contrast of white and black—is far greater than a full palette. I also happen to be very heavy handed, and the resistance provided by a block of wood or linoleum keeps my heavy hand in check.

EH: How would you describe your work and process?

DR: I start each block by drawing my imagery, first in pencil then again in Sharpie. I meticulously draw each detail until it's exactly how I want the print to look in the end. I stain the block red so that I'll be able to see where I've carved and where I haven't—then I start carving. My work is very intricate and tedious. It's not uncommon for me to work on a block continuously for 6 months at a time.

EH: How do you stay creative on a day-to-day basis?

DR: I give myself strict goals and deadlines, and I stick to them. Many times I find myself telling a friend that I can't do something because I have to finish a block, When they ask what the block is for, I don't have an answer for them, there isn't a deadline, it's not specifically for anything, but I can still feel the need and drive to finish it.

EH: Describe the space in which you make your art.

DR: I have an amazing basement studio in my home, and I am super proud of it. It's fully stocked with everything I need to produce woodcuts, linoleum cuts, and silk screens. I have a motorized etching press as well as a letterpress proofing press that I print my relief prints on, a full size drying rack, a guillotine style paper cutter capable of cutting over 200 sheets of paper at a time, a vacuum table, a silk screen exposing unit, and t-shirt press for silkscreen. I literally don't have to leave the house to make my art.

EH: Name one thing you hate about printmaking and one thing you love about it.

DR: There are five emotional stages to making a relief print.
1. The excitement of starting a fresh block
2. The agony of being so close but yet so far from finishing carving the block
3. The anticipation of pulling the first print
4. The depression of seeing everything backward for the first time
5. Acceptance and moving on

EH: Do you have any helpful tricks or "hacks" that you've picked up along the way?

DR: It's very easy to overwork a relief print. Taking frequent breaks is important, not only for health reasons, but also as a visual reset. Plan your block completely, leaving nothing to "figure out later." Rushing into a block is the quickest route to making mistakes.

Even when working with a black and white relief print, there are many grays that can be achieved through carving patterns, hatches, and cross hatches. These hatches and cross hatches will give the print depth. It's important to give the print enough contrast to make the grays stand out. I've found that a balanced print can have at least 20% solid black, 20% solid white, and up to 60% grays. Without enough solid black and white the grays wash out and turn flat.

Tunacorn

Derrick Riley in his studio

Visit Derrick at www.drockpress.com
His work can be seen at: Revelry Gallery (Louisville, Kentucky); Brickaloge Art Collective (Paducah, Kentucky); City Gallery (Lexington, Kentucky); Gather (Bloomington, Indiana); Conspire (Greencastle, Indiana)

EH: What is your favorite piece that you've ever made?

DR: For three years I worked on a series of woodcuts about Kentucky monsters, myths, and legends. It's a 14-piece series of interconnected prints that can be completely rearranged and still line up edge to edge. All together it measures 32 $^{1}/_{2}$ feet (9.9 m) long.

EH: What's one piece of advice you'd give to someone new to printmaking?

DR: I'll give them two. First of all, don't get discouraged, you have 100 terrible prints in you. The quicker you get them out of the way, the sooner you can make something special. And the other one is practical: Keep everything clean all the time. Trying to make clean prints in a dirty shop is a nightmare. I always preclean all my palette knives, rollers, roll up slabs, the press, and especially my hands before I print.

Jackalope

PROJECT:
CONTOUR LINE SKULL

Tools and Materials

8" x 8" (20.5 x 20.5 cm) unmounted linoleum

10" x 10" (25 x 25 cm) printing papers

Pencil

Fine-tip permanent marker

Tracing paper

Carving tools

Washi/masking tape

Inking plate

Black ink

Palette knife

Brayer

Baren

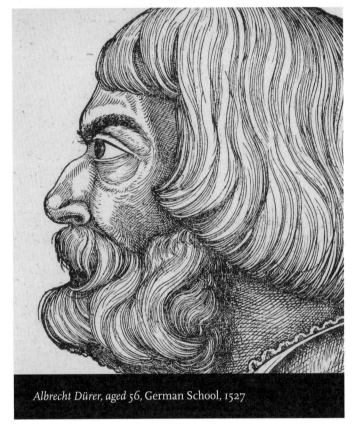

Albrecht Dürer, aged 56, German School, 1527

Contour lines are lines that suggest the form of an object. These lines can be used to show any planar changes within the form.

In diagram 1, you can see how the simple addition of straight lines and then curved lines transform a flat circular shape into a three-dimensional spherical form.

Diagram 2 breaks down the contour lines of a sphere. To see how contour lines suggest volume, start by quartering a circle, then draw lines that bend by varying degrees the farther away from the center line they are.

For a brilliant example, see these contour lines by the master Albrecht Dürer in this self-portrait woodcut from 1527.

Diagram 1

Diagram 2

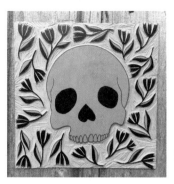

1 Using the transfer method of your choice, transfer your own design onto the block.

3 Carefully carve out the negative space.

2 Lock in the lines with a fine-point marker.

4a

4b

4c

4d

4 Carve out the floral details.

a. Carve out a center line on the leaf.

b. Carve an inner border line on one side of the leaf.

c. Beginning at the center line and sloping downward and to the left, carve vein lines for the left side of the leaf, stopping just before the edge.

d. Beginning at the inner border line and sloping upward toward the center line, carve vein lines for the right side of the leaf.

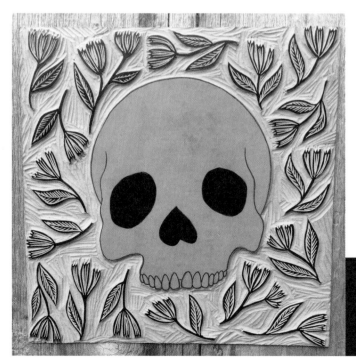

Here is the fully carved out floral background.

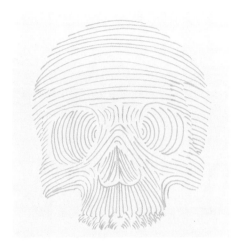

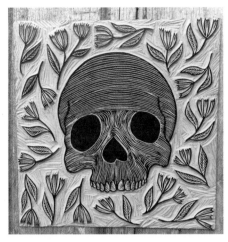

5 Using the contour line guide, lightly draw contour lines across the skull with a pencil. Begin carving out lines that follow the contours of the skull, using a smaller gouge—I used my 1-mm V-parting tool.

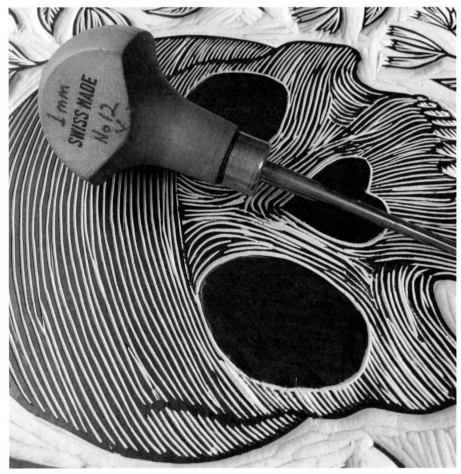

6 Continue until the skull is covered in thin contour lines.

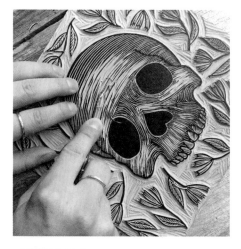

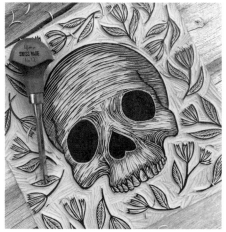

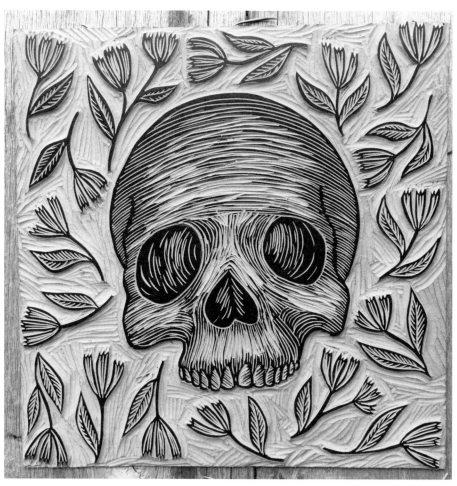

7 Take a second pass at carving, this time with a bigger tool. Here I used my 4-mm no. 12 V-parting tool. Concentrate your marks on the apexes of curved areas (the spots that stick out the most, like the forehead and cheekbones). This will help lighten the value in these areas, making them appear to move forward or appear closer to the viewer.

8 Continue carving until you've achieved a range of values within your form (dark blacks, medium grays, and light whites).

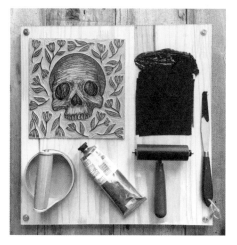

9 Assemble your printing tools and roll out your ink.

10 Make a simple printing jig by tracing the block as well as a piece of the 10" x 10" (25 x 25 cm) printing paper on a larger piece of paper. This will help the print fall roughly in the same spot for each print of the edition.

11 After inking the block, apply paper to the block and press firmly with a baren, burnishing areas with a firmer baren such as a spoon, if necessary.

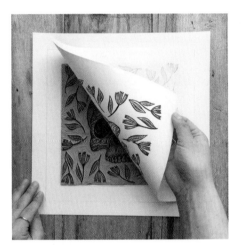

12 Carefully peel the paper back from the block.

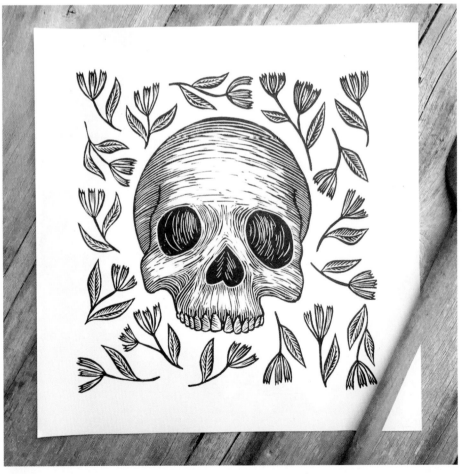

13 Set your print aside to dry.

ARTIST SPOTLIGHT:
KELLI MACCONNELL

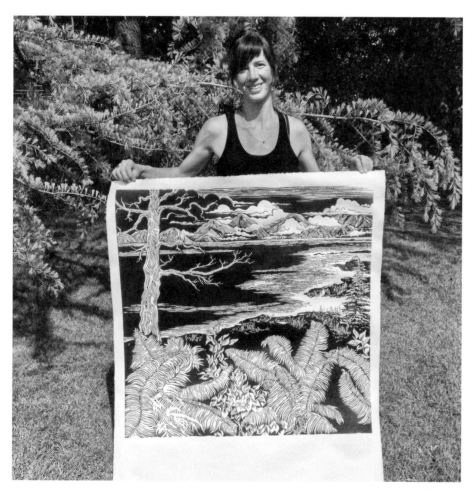

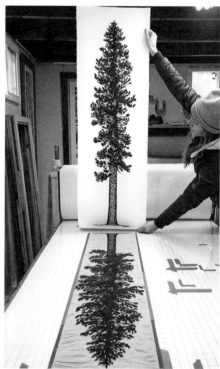

A fearless experimenter, student of the natural world, and talented printmaker, Kelli MacConnell of Portland, Oregon, creates intimate portraits of some of nature's finest specimens. MacConnell's masterful rendering of trees gives them a life beyond the forest, stately and regal, worthy of reverence. Her prints evoke the peace of the natural world and suggest a thoughtful, studied approach, reminding us that direct observation is often one of the best teachers.

EH: How did you become interested in printmaking?

KM: Art has been a love of mine for as long as I can remember. My focus for many years was landscape drawing and painting, and it actually wasn't until my third year in college that I discovered printmaking. I took an intro to etching class and unexpectedly found that printmaking felt like the perfect mix of drawing, painting, and sculpture, which was very exciting to me. I felt like I had opened a door to a new world where there was the possibility to explore the true spontaneity of artmaking. In a lot of ways printmaking is a very calculated operation, but inevitably there is a degree of uncertainty because of the process of transferring ink to paper. I never really know exactly how a piece will look until it is printed. I absolutely love the mystery, suspense, and surprise that awaits me after finishing a carved block.

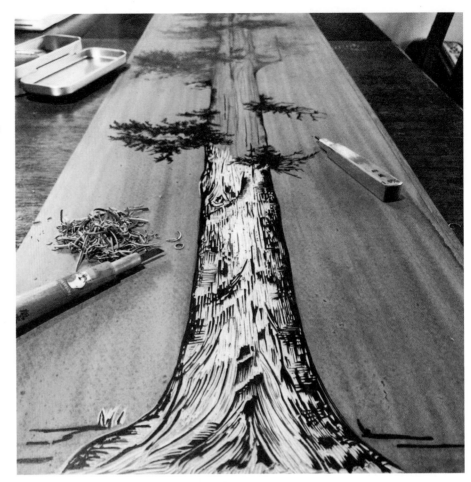

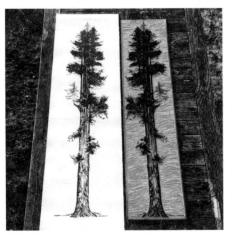

EH: What drew you to relief in particular?

KM: I find I can achieve the graphic images that I set out to create by making linocuts. The color fields of the linocut are rich and uninterrupted by the grain of the wood for example. I'm drawn to the crisp, velvety nature of relief prints.

Also this act of drawing with light, in a sense, holds an innate graphic power that I absolutely love. The idea of taking away to create instead of adding to something has intrigued me from the beginning. In this type of printmaking, shapes are formed by enforcing white or light in the image with carving tools. It's in taking away material from around and within a design that an image will begin to form. This process forces me to deconstruct and abstract the landscape that I'm working from. For me this is a much more challenging undertaking than drawing an image with graphite, for example. I like having to think carefully about mark making

in order to portray texture, depth, shadow, fluidity, and softness with a hard line while simultaneously honoring the balance of lights and darks (because I work mainly in black and white) in each composition. I find it is a sculptural way to make two-dimensional artwork. It's meditative and so satisfying to watch the image come to life in a three-dimensional form on the block. Some may find hours of carving with tiny knives and gouges mundane and tedious, but I find it to be an extremely calming and therapeutic practice. I feel I'm drawn to this process almost on a subconscious level. The familiarity of picking up the tools is calming and comforting. Spending time using these tools to shape and create something makes me feel like I'm spending time in a tucked-away oasis where I can find a flow and focus, a place that heightens my senses while clearing my mind. The tools become an unconscious extension of myself. When I am deep in this place [where] the craft of cutting/carving happens I lose myself to the intuitive energy that emerges from the

emotion and creativity from within.

I also enjoy the process and repeated pattern of movement when creating multiples. I find this step of the process calming and contemplative as well. It is in this rhythm that I notice the beauty and subtleties of each print. Making them their own entity and giving them each their own personality.

EH: How would you describe your work and/or your process?

KM: I would describe my work as graphic, nature-inspired impressions of the wilderness. Creating these pieces brings me joy, and I hope connects others to the natural world as well. I hope that these prints are little reminders of what lies beyond our buildings, windows, phones, computers.

I feel like so many of us have become disconnected from the natural world, and forget that our health is affected by this. I believe contact with nature improves our physical, mental, and emotional well-being. People need to reconnect to the wilderness around them, and it is then that they will feel fulfilled. It is then that they will live a more satisfying life and feel content, and hopefully in turn this will lead to stewardship of the land and the world's wilderness areas.

My current body of work explores human relationship with trees and their form through relief printmaking. I have created my own interpretations of the species that move me in hopes that they will enchant the viewer and evoke feelings of nostalgia, wonder, and peace. This medium allows me to carve away the unessential and use creative subtraction to form a delicate dance between negative and positive space, designing an image and place for contemplation and reflection. With the simple use of contrast, as well as line manipulation, I strive to create absorbing compositions inspired by the West Coast forests.

My process of transforming my experience into a print involves reversing the image from my sketches onto the relief surface, then carving away the negative space or the

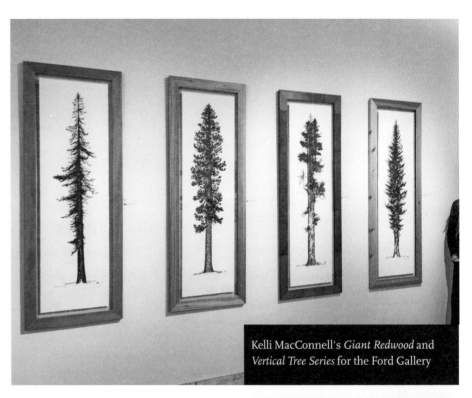

Kelli MacConnell's *Giant Redwood* and *Vertical Tree Series* for the Ford Gallery

areas I would like white. After the block is complete, I roll a thin layer of ink onto the block with a brayer, gently place damp cotton-rag paper on the inked surface of the block, and roll it through a press to transfer the image onto the paper or make an impression of the image onto the paper. I usually publish editions of 20–100 prints.

EH: Sometimes we have a love/hate relationship with our passions. Name one thing you hate about printmaking and one thing you love about it.

KM: One of the things I find frustrating about printmaking is that occasionally I feel like the process and the steps I'm taking to create a print are the same as I've done before, yet I don't get the outcome I had planned or predicted; this is actually exactly the same thing I love so much about printmaking. In the same breath, I love the unexpected surprises that happen when printing that I can learn from. I suppose it depends on if I'm excited about that surprise outcome or not!

Visit Kelli at www.kellimacconnell.com.

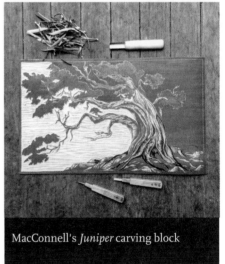

MacConnell's *Juniper* carving block

Tools and Materials

- 10" x 10" (25 x 25 cm) unmounted linoleum
- 12" x 12" (30.5 x 30.5 cm) printing papers
- Additional colored paper
- Tracing paper
- Pencil
- Fine-point permanent marker
- Carving tools
- Washi/masking tape
- Inking plate
- Palette knife
- Brayer
- Baren
- Adhesive
- Gouache or watercolor paint and palette
- Water cup and towel
- Small paintbrush
- Craft knife
- Self-healing mat

Sometimes when designing a new print, I want just a little pop of color to really make my composition shine. Such small areas of color rarely warrant their own block, so that's when I like to apply color by hand. This project details how hand painting and collage can enhance an otherwise simple black ink print.

Note: It's generally best to use a sturdier, thicker paper as the "support" paper, collaging thinner papers onto it. For this project, I printed on heavyweight tagboard and the collage elements are printed on a lighter, textured coral scrapbooking paper.

1 Design and plan your print, noting which areas of the print will recieve color via paint or collage. Because this design features a black raven in the center, I plan to apply color in the floral background—hand painting the blueberries and collaging the flower buds.

2 Transfer your design onto the block using the method of your choice, and lock the drawing into place with a fine-point permanent marker.

3 Begin carving the background, protecting small details by first carving outlines with a small V gouge (I used the Pfeil 1-mm no. 12 V-parting tool) and then clearing the negative space.

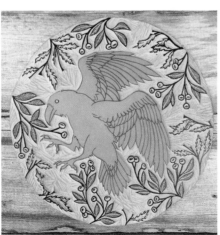

4 After clearing the negative space, start on the florals. Notice that the flower buds have disappeared from the composition. They will be printed separately on different paper.

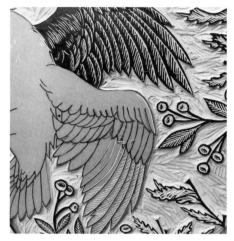

5 On the body of the raven, highlight the contours of the feathers using intentional, directional lines. A straight line can suggests a flat plane, and a curved line suggests a curved plane (use the knowledge you gained from the Contour Line Skull project on page 74). It can be helpful to go over your carved areas with a thick permanent marker to check your work and get a sense of how the block will look when it prints.

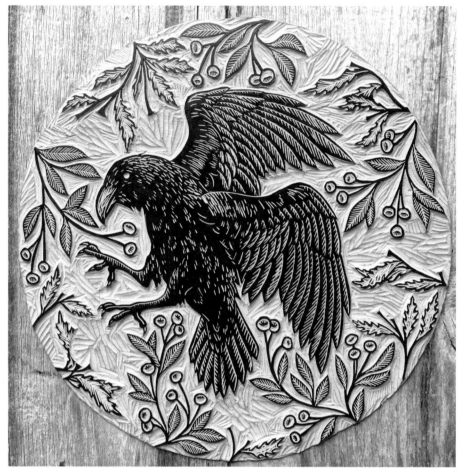

Carve the raven's talons

6 Using small, short strokes with a 1-mm V-parting tool, carve the suggestion of the raven's body feathers. This will make it appear as if the feathers are catching light, and gives the form a more definite sense of volume. Once the block is fully carved, set it aside.

7 The design calls for eight bigger flowers and seven little buds. Transfer the designs for the bigger flower and little bud onto a scrap piece of unmounted linoleum and carve them (since they repeat in the composition, you only need one of each). Now we're ready to print!

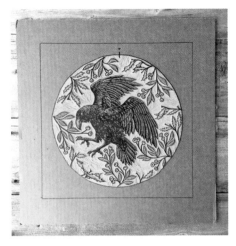

8 Set up a simple printing jig using a large sheet of paper or a scrap piece of cardboard. Trace a template for your printing paper (12" x 12" [30.5 x 30.5 cm] square). Position the block in the center and trace around it.

9 Since the design is circular, I've indicated the top in order to give each print in the edition exactly the same orientation. Make a mark at the top of your block with a permanent marker, and extend that mark off of the block and onto the printing jig. Each time you lay the block down, make sure these marks line up.

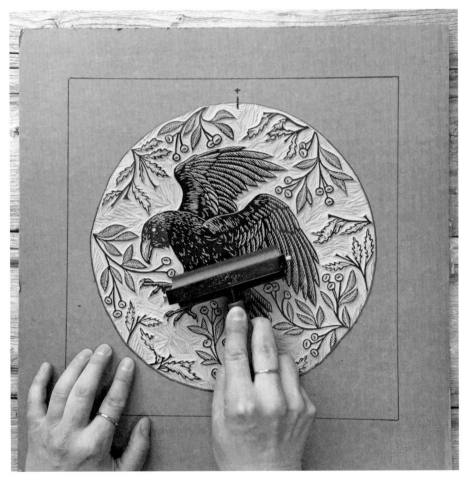

11 Carefully lay a sheet of printing paper onto the block and press with a baren, coaxing out fine details using a firmer baren or spoon if necessary.

10 Spread a small amount of black ink onto your inking plate and roll out. Apply to the block.

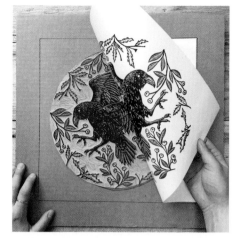
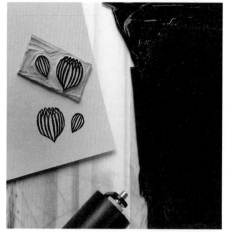
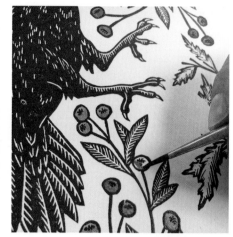

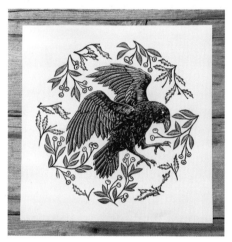
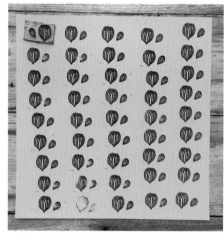
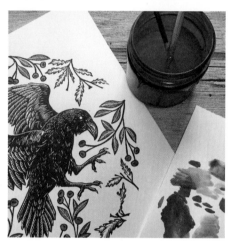

12 Gently peel the print back from the block to check for any areas you may have missed. Set the completed print aside to dry.

13 Take the small flower block and apply ink. You might want to use a smaller brayer for this one, unless you don't mind a mess!

14 Remove excess ink from your blocks and clean all your tools and surfaces. Let your prints dry before moving on to the next steps.

15 We can begin embellishing the now-dry prints, starting with paint. Mix paints with a brush on a palette until you get your desired color. I recommend using watercolor or gouache and testing the paints on a scrap piece of paper before you begin painting on your prints. Taking care not to overload your brush with too much paint or water, carefully paint in each blueberry. If you printed with an oil-based ink, you'll notice how the paint naturally resists the ink, making it a little bit easier to stay inside the lines. Once the painting is complete, clean your materials and set the print aside to dry.

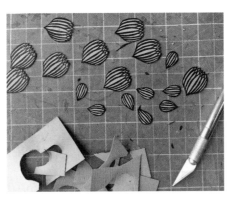

16 Using a craft knife and self-healing mat or other cutting surface, carefully cut out eight big flowers and seven little buds. It is important to be aware of the blade at all times, never pulling it directly toward your body. Replace the cap when not in use.

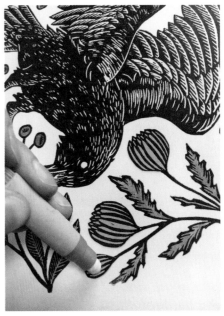

17 Refer to the original drawing as a map to show you where to place the flowers. Apply adhesive to the back of each flower, position it on the print, and press it with your (clean) finger or with the (clean) rubber end of your pencil. Repeat for each flower and bud. Once each has been applied, place the print under a heavy stack of books to keep it from warping as the adhesive sets.

18 Repeat as per the size of your edition.

The final product, a bit spiffed up

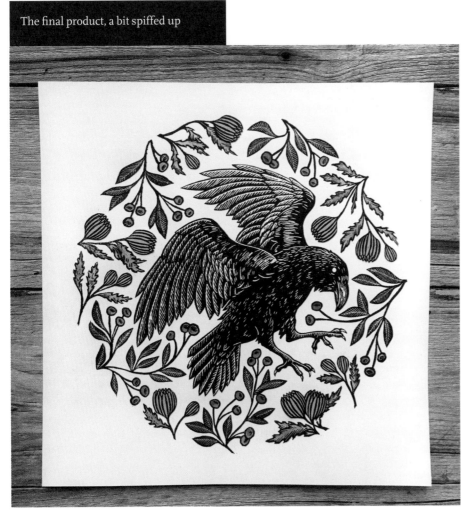

ONE-PAGE POCKET ZINE

Tools and Materials

8 ¹/₂" x 11" (21.5 x 28 cm) unmounted linoleum

Drawing paper

Tracing paper

Pencil

Washi/masking tape

Carving tools

Ink

Brayer

Inking plate

Palette knife

Baren

Scissors

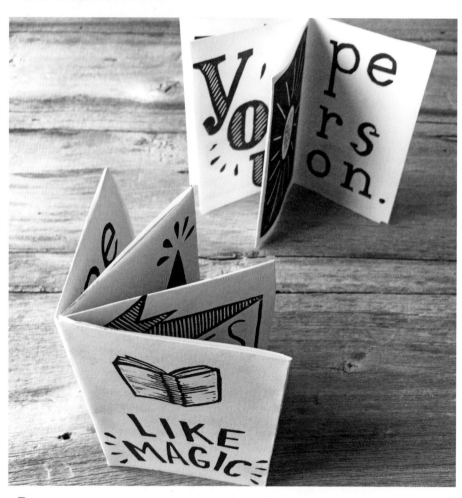

Perhaps the greatest legacy of printmaking is its role in democratizing knowledge. The advent of Johannes Gutenberg's movable type press in 1436 allowed for faster production of printed materials in Europe; books became more widely available and the working classes gained literacy. Given this history, we would be remiss to leave out text in our linoleum prints.

Part of the appeal of printmaking is the potential for nearly limitless multiples, so it's the perfect medium for creating your very own zine to distribute. A zine is a self-published, small-circulation book or magazine that is usually photocopied and hand bound. For this project, you'll be making your very own hand-bound and hand-printed zine out of one standard U.S. letter size (or A4) sheet of paper.

Zines originally emerged as science-fiction-fan magazines in the 1930s, picking up in popularity again with the rise of *Star Trek*, but then quickly spread to the music scene. The proliferation of copy shops in the 1970s and 1980s along with DIY aesthetic of punk music caused the creating and trading of zines to expand because of quicker and cheaper distribution. Zines today vary a great deal in size, style and content.

Make a Plan

Decide what you want your zine to be about, and then start designing and planning each page. Keep in mind that we're only going to have six usable "content" pages—you will have eight pages in total, but two of those are the front and back covers. Each page will end up measuring 4 1/4" x 2 3/4" (10.8 x 7 cm) and will be oriented portrait.

Having trouble thinking of an idea? Here are some potential titles to get your brain churning.

Things I Know for Sure

A Simple Recipe

A 6-Line Poem About Hope

A 6-Word Poem About Breakups

A Word of Advice

A Letter to My Haters

Things I Love About You

What I Wish I'd Said

How to Make Friends with a Baby

Lies I've Told

A List of Favorite Foods

A Public Service Announcement

Things My Dog Would Say

Illustration 1

1 Grab a piece of 8 1/2" x 11" (21.5 x 28 cm) paper. Fold lengthwise once (like a hotdog bun), once again widthwise (like a hamburger bun), and then (hamburger) once again, as in illustration 1.

Unfold the paper. You should have eight equal rectangles measuring 4 1/4" x 2 3/4" (11 x 7 cm).

Orienting the paper in the landscape direction, label your covers and pages as in illustration 2 .The rectangles on the top half of the sheet will be upside down, and the rectangles on the bottom will be right side up.

2 Transfer your drawing to your block with the method of your choice (see Transfer Methods, page 32).

Illustration 2

3 Double check that your text as it appears on the block reads backward, then ink in your block with a permanent marker.

4 Carve out the negative space.

5 Spread out about a quarter-sized dollop of ink onto your plate. Add a drop of cobalt drier, if desired. Warm up the ink or mix in the cobalt drier by spreading it around with a palette knife. Roll out to an even consistency with the brayer.

6 Carefully roll ink onto the block, taking care not to hit large areas of negative space with the brayer.

7 Line up the edge of your block with the edge of your paper and press the paper firmly to the block. With the block on bottom and paper on top, hold the paper in place while applying firm, even pressure with a baren.

8 Set the baren aside and carefully peel the paper away from the block. Set the paper aside to dry.

9 Print as many as desired, clean all materials, and set the prints aside to dry.

10 Once all pages are completely dry, you can assemble them into booklets. Just as you did with your original sketch paper following illustration 1, fold the paper in half lengthwise (hotdog).

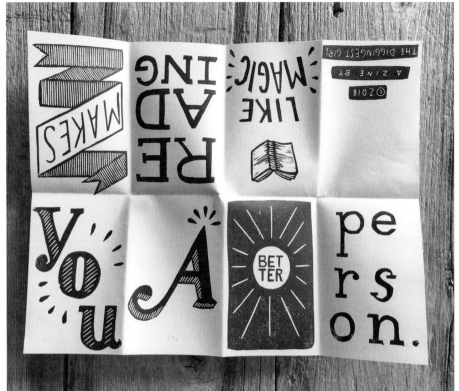

11 Fold it in half again widthwise (hamburger).

12 Fold it in half once more and open the paper back up.

14 Open the paper back up and refold it lengthwise, with the printed side of the paper facing out.

13 Fold the paper in half widthwise, and with a pair of scissors carefully cut only along the fold between the middle pages. Don't cut your paper in half!

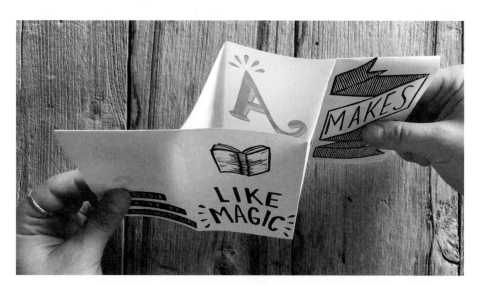

15 Pinching the ends of the paper together, push your hands together to make the cut open up and the middle pages pop out.

16 Open up one end and push the interior pages inside of the covers.

17 Fold shut, ensuring that your covers are on the outside

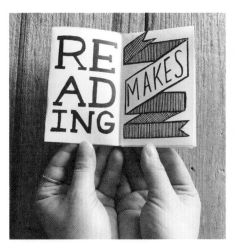

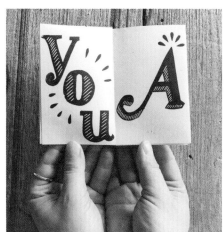

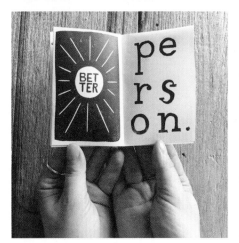

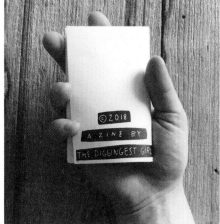

18 Repeat for all prints, and then congratulate yourself. You've just self-published your own zine!

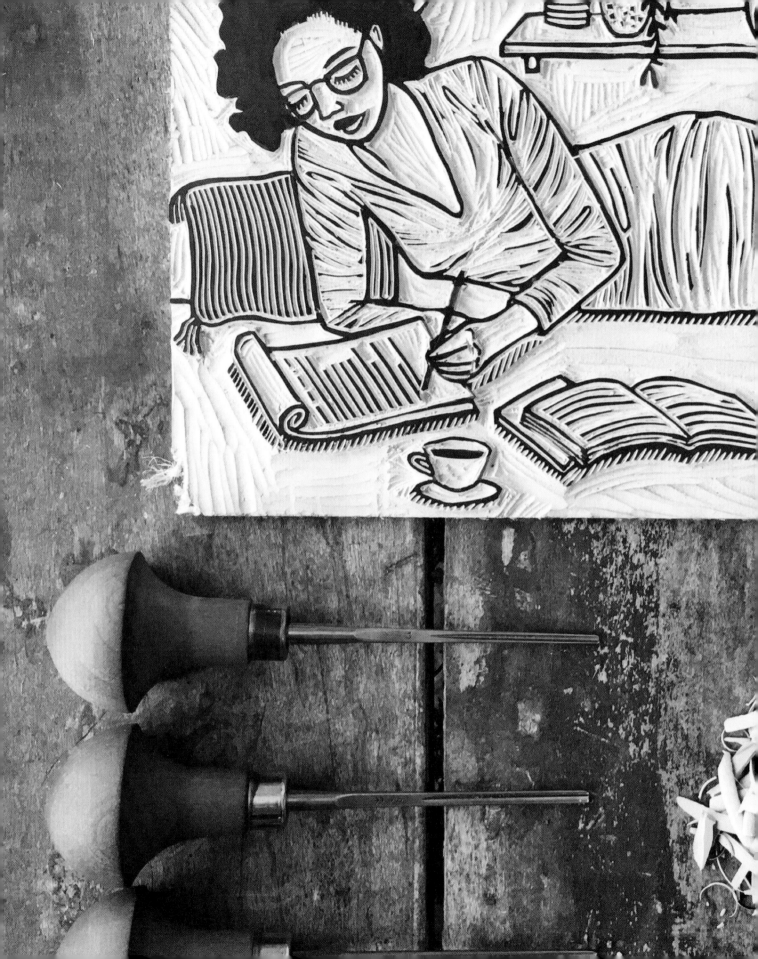

CHAPTER 4

TARGETED TECHNIQUES

E xploration and experimentation are essential to artistic growth and are reliable routes to discovering your own voice. The following projects will help you stretch your creative muscles: using uncommon methods to alter paper, making a multi-color print with a single pull, and crossing disciplines with fiber arts to name a few. In this chapter, three contemporary printmakers will show us a wide variety of techniques from sweeping landscapes to divine color gradients to possibilities of print on textiles.

PROJECT:
PUZZLE BLOCK PRINT

Tools and Materials

Scrap pieces of Speedy-Cut carving blocks

7" x 9" (18 x 23 cm) printing papers

Pencil

Tracing paper

Carving tools

Washi/masking tape

Inking plate

Three different ink colors

Palette knife(s)

Brayer(s)

Baren

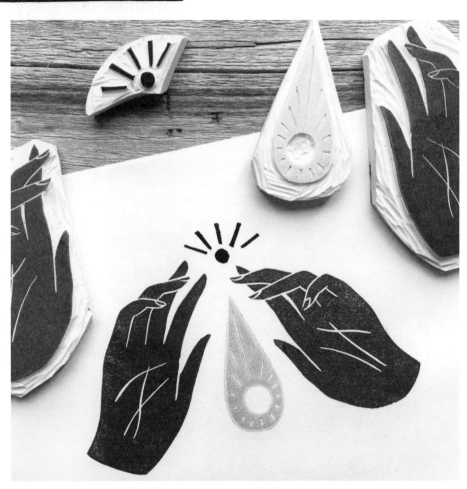

One simple and efficient way to make a multi-color print in a single pull is by utilizing the puzzle-block method: individual blocks, inked separately, but then assembled and printed as one. You can start with a simple design, like this one, or make one as complicated as you wish with as many pieces and colors as you dare! For projects such as this, I like to use the softer rubber blocks rather than the more firm linoleum, because the rubber cuts smoothly with very little effort, making intricate or small pieces easier to cut out.

1 Design your print, using two or more colors. Transfer your design to scrap pieces of Speedball Speedy Cut (I used the tracing paper transfer method).

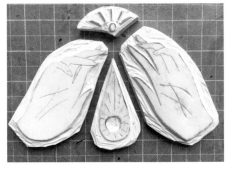

2 Carve out your design, carefully cutting elements apart with a sharp craft knife. Use a self-healing mat to protect your work surface.

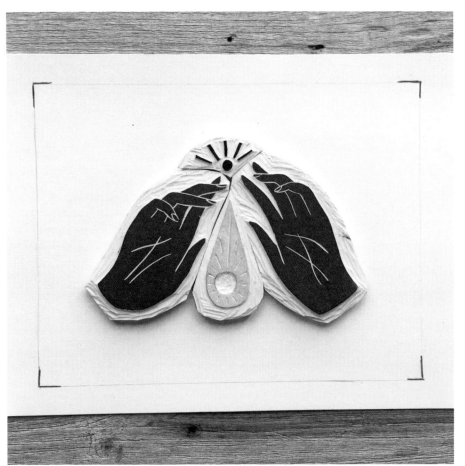

3 Make a simple printing jig: With a sharp pencil trace a sheet of 7" x 9" (18 x 23 cm) printing paper on a larger sheet of paper. Arrange the blocks within this border and trace around the blocks.

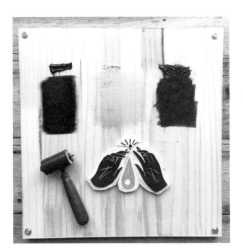

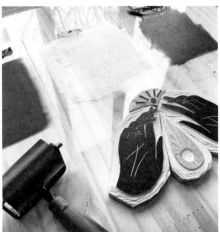

4 Select and mix the colors for each block. (I used Caligo SafeWash Relief inks in naphthol red, raw umber, burnt sienna, and black, and Schmincke Aqua Linoprint ink in gold.) Spread and roll out the inks, and apply ink to the blocks using small brayers.

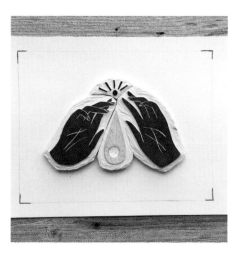

5 Arrange blocks in the printing jig.

6 Lay a printing paper down on the blocks, pressing very lightly with a padded baren. Speedy Cut is a very soft and malleable material and is prone to bleeding if too much pressure is used during printing.

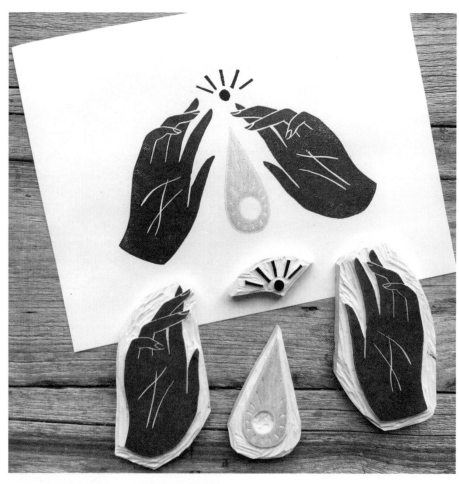

7 Carefully peel the paper away from the blocks. Set it aside to dry.

PROJECT:
UNCOMMON GROUND

Tools and Materials for Printing

4" x 6" (10 x 15 cm) rubber block

Pencil

Fine-tip permanent marker

Tracing paper

Carving tools

Washi/masking tape

Inking plate

Black ink

Palette knife

Brayer

Baren

Tools and Materials for Groundwork

5" x 7" (12.5 x 18 cm) printing papers (medium to heavy weight)

Tissue paper

Adhesive (I used Mod Podge matte finish)

Glue brush

Watercolor/gouache, paintbrushes, and water cup

Salt

An old book or magazine

Unused black tea bag

Needle and thread or sewing machine

Toned/colored paper

Soft colored pencil or crayon

Craft knife or hole punch

Self-healing mat

"Ground" refers to the background surface on which a print impression is made. The most common ground is plain paper, as received from the manufacturer. Sometimes preparing the ground beforehand can yield interesting results, however, changing the entire mood of the final print.

Playing around with ground is a fun and easy way to experiment, especially when you feel stuck and stale in your practice. But don't stop with the suggestions here: challenge yourself to think of additional ways to manipulate the surface of your paper and push the boundaries of your creativity. This project focuses on the printing ground, so the design and execution of the block is up to you. You know the drill.

1 Design, transfer, and carve your block.

2 Create a simple printing jig by tracing your block and the printing paper.

3 Ink up and print with a baren, using lighter pressure for softer blocks with fine details.

For each of these processes, allow the prepared papers to dry fully before attempting to print on them. Any process involving moisture will cause the paper to curl or warp. You can press the dry papers under a stack of heavy books to combat this. I suggest using a softer rubber block for this project, as the more pliable surface will allow you to better push ink into uneven printing surfaces.

Groundwork: Book Club

This is an easy one: simply cut or tear a book or magazine page to size and print. You could further manipulate the message/meaning of the print by redacting, circling, or underlining words on the page in order to form your own message from the present text.

Groundwork: Tea Party

Use a fresh, wet tea bag to stain plain white printing paper. You can lightly drag the bag across the paper to create a solid wash or you can blot the bag to create interesting patterns and textures.

Groundwork: Tissue Layers

Using a glue brush and matte-finish adhesive, arrange torn bits of tissue paper on heavier-weight printing paper and glue into place, sealing over the top.

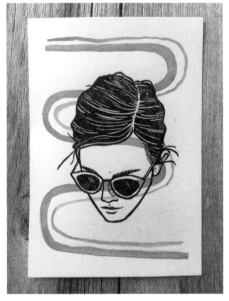

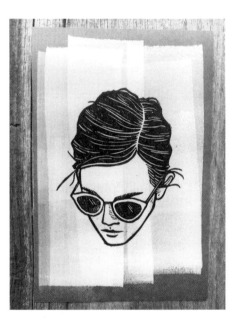

Groundwork: Paint Job

Add color, pattern, and extra visual interest to an otherwise simple print with paint experiments. Try painting different patterns and playing with different colors to achieve different moods. Paint precise patterns on dry paper or fluid washes on paper first wet by a clean, watery brush. Try adding a pinch of salt, as salt sprinkled on a wet wash will cause the pigment to gather, resulting in a mottled effect. Brush the salt off after the paint is dry, and before you print.

Groundwork: Brayer Blot

I often have precut papers lying about from other projects. Sometimes during cleanup I blot my brayer on these papers instead of old magazines. This cleans excess ink from the brayer while also giving me a cool, layered print surface for future experiments like this one! Simply roll your brayer, loaded with any color ink onto any color paper.

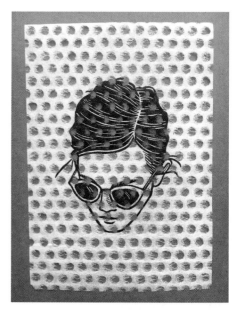

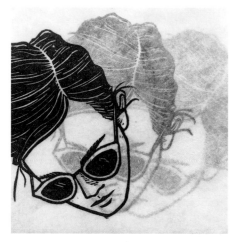

Groundwork: Transparent Layers

Although this one isn't technically a specially prepared ground, it is still a cool effect. Print onto sheets of transfer paper and play with layering these prints in various arrangements until you hit on a composition you like.

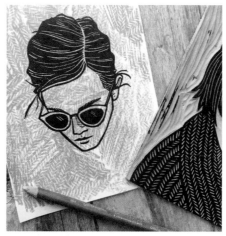

Groundwork: The Rub

A fun way to utilize old blocks is to create texture rubbings from them. Try using your block from the very first project, the Texture Quilt! Place your printing paper on top of your (clean, dry) previously used block and rub with the tip of a crayon or soft colored pencil. Shift the paper as you go to break up patterns.

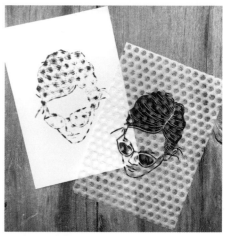

Groundwork: Holes

I purchased this paper from a specialty paper shop (see Resources, page 150) to use in collage work. Try printing on paper that you punched holes in or cut in patterns with a craft knife and self-healing mat. When printing on paper with pieces cut out, make sure to place a "buffer" piece of paper behind cut out areas as you print. This will keep the printing area clean of ink and the backs of subsequent prints clean as well. Mount onto a piece of contrasting paper.

Groundwork: In Stitches

Having enjoyed sewing since childhood, I'm always trying to find ways to sneak stitching into my printed projects. I treated these heavyweight tagboard printing papers just like fabric and stitched directly onto them, using my sewing machine and taking care not to tear the paper as I went. Since I couldn't efficiently tie any knots or back up the stitches, I placed tape on the back of the papers to hold the stitches in place.

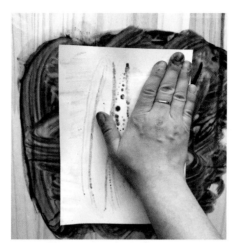

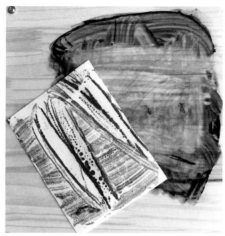

Groundwork: Cleanup Crew

When cleaning up after another project, I noticed that the lines created by my wiping made its own kind of drawing. Before all of the ink is fully wiped from your inking plate, blot the plate with a clean piece of printing paper.

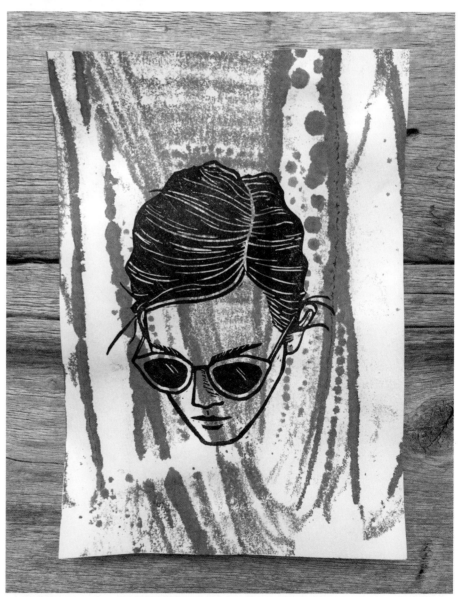

ARTIST SPOTLIGHT:
AFTYN SHAH

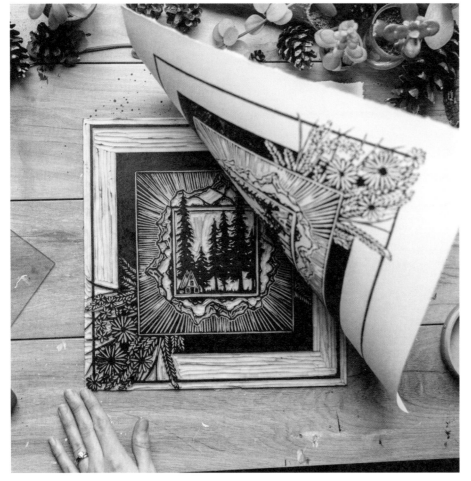

Crafting exquisitely detailed landscapes from her studio outside of Philadelphia, Pennsylvania, printmaker Aftyn Shah explores inspiration and restoration that nature provides. Her studio practice is named Rise + Wander, a call to adventure, beckoning the viewer outdoors. Shah's lyrical, playful linework forms bold compositions that seem to breathe with a life all their own.

EH: How did you first become interested in printmaking?

AS: My husband's family comes from India, and I've developed a huge appreciation for the textile industry there—particularly the block printing! I've received pieces as gifts and was always in awe of the craftsmanship. Looking for a creative outlet a few years ago, I got it in my head that I wanted to make a scarf, and I headed to the nearest craft store to buy all the supplies. I ended up only printing on paper, but I haven't stopped since then—and I still haven't made my scarf!

EH: What drew you to relief in particular?

AS: I love that it removes the need for perfection. Previously, I had always painted or drawn, artforms that involve adding, adding, adding, until the piece is as close to the idea in my head as possible. And nothing ever reached that level, which is disappointing and frustrating, even disheartening. With relief printing, the process is reductive. I tend to work in only black and white (or maybe just a few colors), and I can only remove so much before the piece starts to lose balance. At some point, I have to just stop. I have to step away. There isn't the sense that I can just add on forever, trying to reach perfection. That's freeing. Also, I love the more rustic aesthetic, with the occasional wisp of errant ink or a little patching. It makes each piece individual and its own work of art.

EH: How long have you been working as a printmaker?

AS: My first print was a Valentine's Day card for friends in 2015, and I gradually picked up the pace in my creations over that year, before really dedicating time in the beginning of 2016. I started Rise + Wander in January 2016, and I've made it a point to work on something almost every day, even if it's only for ten minutes.

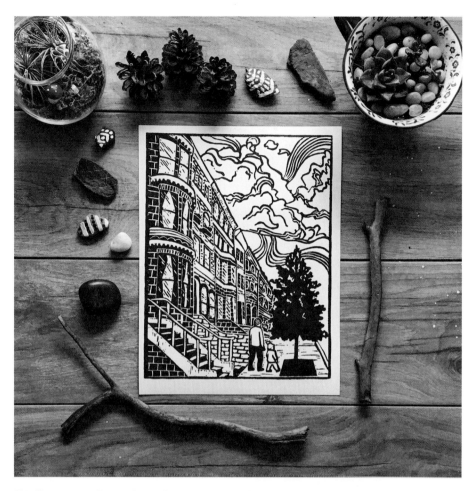

EH: How would you describe your work and your process?

AS: In a word? Slow. With two young sons, the rhythm of my life—including my art—is set by their schedules. I often have to find time to work between their needs. For this reason, I generally have thought about a design for hours or days, sometimes even weeks, before I actually sketch it out. Because I don't have as much time as I'd like, I minimize steps where possible, like drawing something out directly on the block. Then, depending on how life goes, it can take weeks to finish even a smaller block. I used to get impatient and frustrated with this slower schedule, but I've begun to welcome the pace. This way, I can return to it each time with fresh eyes and evaluate the direction I'm headed with it.

EH: What are your main sources of artistic inspiration?

AS: Definitely nature in all its forms. The majestic, the tiny, the wild, the beautiful. I love taking a walk with my family or hiking by myself and mentally outlining everything. I like to think about how I would represent different details and textures in black and white lines and marks.

EH: How do you stay creative on a day-to-day basis?

AS: I actually think it's easy for me to stay creative on a daily basis because I'm so limited in time. I spend a lot of my day thinking about ideas, taking in different elements (creative projects my son is working on, our beautiful houseplants, views during hikes, for instance) and synthesizing. As a result, I have a lot of excitement built up when it's time to finally execute.

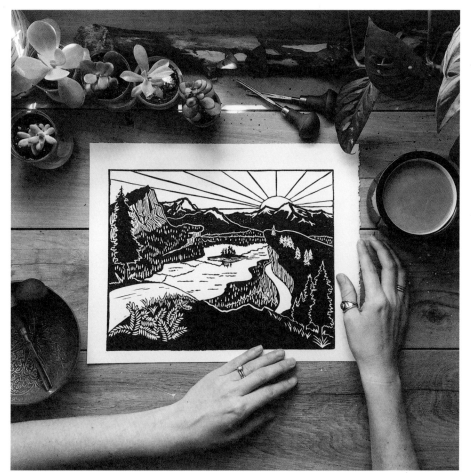

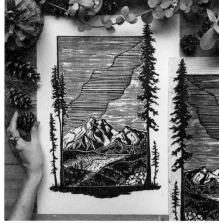

EH: Describe the space in which you make your art—do you have a home studio, rent space, or use a print collective?

AS: I work out of a home studio, which we converted from our formal dining room. It's a nice, big, and fairly light-filled room that allows me to work close to my family—to bounce back and forth between my roles. My favorite part is a giant hand-me-down rug my in-laws gave us that takes up most of the floor. It's a simple design, but it makes the space comfortable and pretty.

EH: What's the best advice you've ever been given as an artist?

AS: Not everyone is going to like what you create. When we're creating, we're putting something of ourselves into our work in one way or another, and when we share it with the world we obviously want it to be appreciated. Unfortunately, not everyone is going to share our taste or our vision, and we just have to accept that. It's important not to take it personally. As much as we invest in our work, just be sure you like it, so you have the confidence to shrug it off when someone criticizes it or even hates it.

EH: If you could spend a day in the studio with three artists you admire (living or dead) who would you choose?

AS: Emily Carr, Frida Kahlo, and Jane LaFarge Hamill. Each has such a different, well-defined vision, and I would love to just bask in their brilliant talent.

Visit Aftyn Shah at www.riseandwander.com

PROJECT:
LIVING LANDSCAPE

Tools and Materials

8" x 10" (20.5 x 25.5 cm) unmounted linoleum

9" x 12" (23 x 30.5 cm) printing papers

Pencil

Fine-tip permanent marker

Tracing paper

Carving tools

Washi/masking tape

Inking plate

Black ink

Palette knife

Brayer

Baren

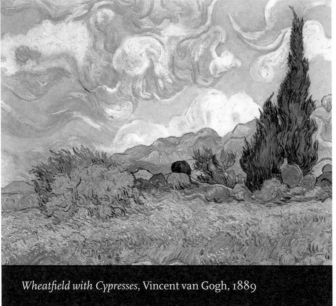

Wheatfield with Cypresses, Vincent van Gogh, 1889

Usually my advice is to work from observation and trust your eyes, but this project has you do quite the opposite. The memory of a place can often be more vivid, more inventive, than a traditional study *en plein air* or from a photograph. Allow your expression to evolve by gradually removing the burden of reality from your landscape.

Visit a place. Take in the mood. Allow your senses to do the drawing. With your eyes, trace the path of flotsam rushing down a creek. Smell the leaves underfoot and notice their mottled repetition on the forest floor. Listen to the wind crashing through the trees like waves. Watch the clouds boil and tumble across the sky as the sun bleeds into the horizon. The land is alive, and you can inject that same life into your composition.

Return to the studio and record your impression of that place by making sketches. Try drawing from the shoulder, which keeps lines loose and allows them to sweep across the picture plane. I also recommend studying the brushstrokes of such notable post-Impressionist painters as Emily Carr and Vincent Van Gogh. Here we have Van Gogh's 1889 *Wheatfield with Cypresses*, where the land appears to undulate and wave. The short, staccato marks in the foreground suggest a dense field, while the longer brushstrokes in the trees fade off into wisps, giving the design more room to breathe. With each mark, Van Gogh suggests the presence of wind and directs our eyes across the page. Though his medium was oil paint on canvas, the same ideas apply to the marks you make with your carving tools.

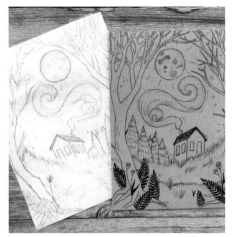

Keep in Mind

An established foreground, middleground, and background will give the composition balance.

Focused, directional lines that move across the plane will help you achieve the impression of movement in an otherwise static scene.

A wide variety of line widths and lengths will allow you to add texture, energy, and depth to the scene.

1 Starting with a memory of a bonfire on a farm with friends, I sketched up a nighttime landscape that attempts to echo the feeling of that night. I established a foreground with two late-autumn trees acting as a frame for the entire scene, ferns growing at their base. The middleground includes the grasses, pine trees, and cabin. Smoke from the chimney reaches into the black night sky background with a smattering of stars.

2 When I have a drawing with lots of visual information, I like to transfer the drawing directly to the block by taping it in place and rubbing firmly with the butt of a marker. After a successful transfer, I inked in the lines, making edits as I went along.

3 Desiring to keep my landscape as loose as possible, I didn't want to plan my marks too much. Carving intuitively can be a bit scary, but the expressiveness of your lines may surprise you! Below are details on how I carved the block.

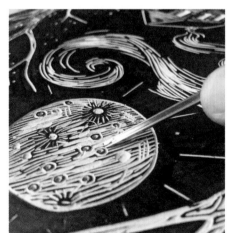

Moon detail: I used contour lines (see Contour Line Skull project, page 74) to give the moon a little bit of volume, curving my marks in accordance with the form, experimenting with craters and pocks. Here I used a 0.5-mm veiner as well as a 2-mm U gouge.

Pine tree detail: Tiers of short cuts with a 1-mm V-parting tool created a stylistic pine tree. Clumping the marks closer together on the right side of the trees act as a highlight, suggesting reflected light from the moon and giving the illusion of volume.

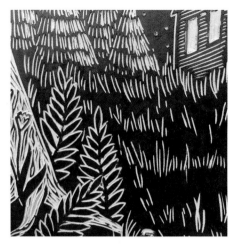

Ground detail: As the foreground is closest to the viewer, I included more details here. I added in small flowers and ferns, and used small clusters of narrow, wispy, upward strokes to suggest grass receding into the distance.

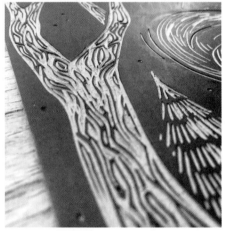

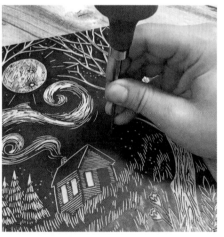

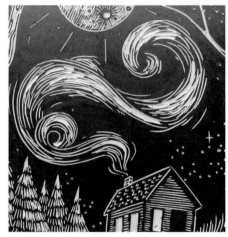

Frame tree detail: Inspired by the cypress trees that are heavily featured in Van Gogh's body of work, I used my own photo of bald cypress bark to inform my marks. First I outlined the trunk and branches to set the trees apart from the background, then I allowed my interior cuts to cross over one another, come together, and wander apart.

Star detail: To make the tiny holes that read as stars, I held a 0.5-mm veiner perpendicular to the block and gently pushed it straight down until the blade bit in, and then twirled it in place. Instead of spreading the stars evenly across the sky, I decided to cluster them together slightly, meandering upward like a stream.

Smoke detail: Lack of a definite outline keeps the smoke looking loose, as larger spaces between the marks suggest more air. Long, swirling lines appear playful, and further assist in directing the eye around the composition. I used a 1-mm V-parting tool, 0.5-mm veiner, and a 2-mm U gouge to ensure variety, the larger marks appearing to catch more light.

Cabin detail: Repeating parallel lines mimic timber and reinforce perspective. Tiny notched tick marks suggest shingles on the roof catching light from the moon.

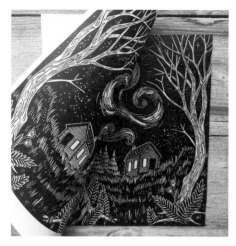

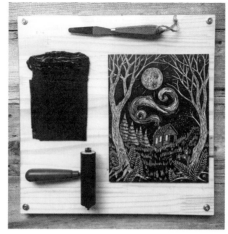

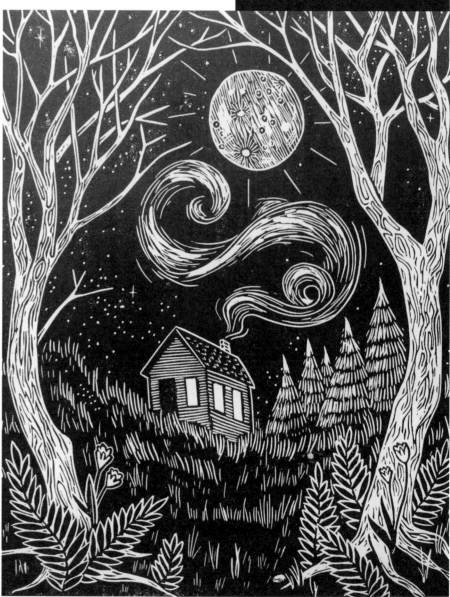

4 Print as usual (see Printing Techniques on page 40).

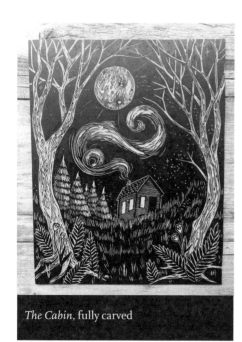

The Cabin, fully carved

ARTIST SPOTLIGHT:
LILI ARNOLD

The work of Lili Arnold is instantly recognizable: her colorful block prints are executed with practiced craftsmanship and fueled by a love of nature, especially the flora of her California homeland. Colors blend seamlessly into one another, lending a soft richness to the surface of her prints. Arnold's compositions are beautifully balanced with a wonderful variety of lines. Read on for a deeper dive into Arnold's creative practice.

EH: What drew you to relief in particular?

LA: I was drawn to relief printing as first because of its practicality. I don't have a real art studio or much space to create art, so relief printing has been the perfect solution because I can make prints without a press and with just a few materials: ink, paper, rollers, and a block. When I first started I used a wooden spoon to burnish my prints, but eventually upgraded to a plastic baren, and now I hope to upgrade to a press someday!

What started as something practical really turned into something that I truly loved. I think part of my deep love for relief printing comes from the meditative process of carving the block, and of course printing it in peaceful repetition. I also appreciate the fact that anyone can try it at home; it's a great art form because it's accessible to all ages, styles, budgets, and spaces.

EH: How would you describe your work process?

LA: My process is simple, low tech, yet still so satisfying. Working without a press, without multiple layers, and without a real studio has pushed me to figure out alternative ways of being efficient and productive. Through these challenges I was able to create methods that really worked for my subject matter and lifestyle.

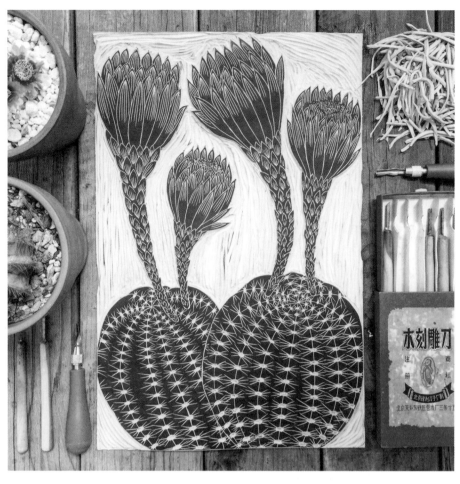

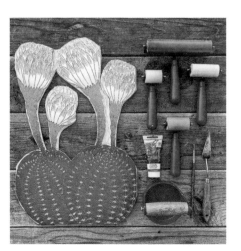

EH: What are your main sources of artistic inspiration?

LA: I am constantly inspired by nature. Whether it's the cacti growing in my backyard, or extremely intricate sea creatures at the aquarium, or the colors of a forest after a light rain. I am always humbled and awestruck by the natural world around me. I also love looking through books of scientific illustration, folk art, and poster art. Something about the tangible pages of a book connects me to what I'm looking at much more than a screen. That said, I do however love Pinterest for organizing ideas and themes, and finding more specific sources of inspiration for a particular project.

EH: What other art forms do you dabble in?

LA: I dabble in a little bit of textile design (both handmade with hand-carved blocks and hand-drawn illustration), watercolor, typography and lettering, and music. I love almost any art form that's hands on; there's just not enough time in the day!

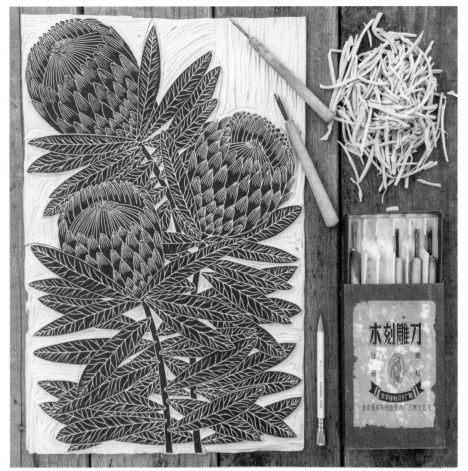

EH: How do you stay creative on a day-to-day basis?

LA: To stay creative and productive requires organization, planning, and lots of daydreaming; but there are a few things that really help me stay on top of things. First, having a sketchbook allows me to keep all my ideas in one place, so I always have a project ready to go. Second, making to-do lists has been a total game-changer for my productivity and confidence.

Running my business can get a bit overwhelming at times, but my to-do lists keep me on track and ease my mind, which allows for creativity to continue to thrive among the stress that might otherwise be debilitating. Also, it feels so good to cross out items on a to-do list! Oh the little pleasures. If I'm ever feeling really creatively stumped, I will usually try to immerse myself in the outdoors if I have the time. Whether it's a hike, a trip to the local arboretum, or just a walk along the beach, getting away from my laptop, or the tall pile of paper I need to tear, or the blank page impatiently waiting for my pencil, or the noisy frat boys that live next door really helps me clear my mind. I usually find that the creative block just dissipates and new ideas start flowing back in.

EH: Describe the space in which you make your art.

LA: My art studio is my bedroom and sometimes my living room. Surprisingly I am able to be quite productive in these small spaces! I think because I don't have a press, it makes for a more contained environment that doesn't take up too much room. It's nice to work at home because I can get started on a project at any point, while balancing freelance design work, making meals, and spending time with my husband. Though working at home can cause some clutter (especially when I'm working on a large edition—prints on the bed, floor, clothesline), I try to clean up and put everything away after every printing session to keep the house feeling peaceful and put together. My equipment is very basic: Speedball linocut tools, Soft-Kut rubber blocks, Speedball water-based inks, rollers, barens, and Stonehenge papers.

EH: Do you have any helpful tricks or "hacks" that you've picked up along the way?

LA: One of my most useful tricks with my botanical prints is using the "puzzle method" in which I cut out the pieces that need to be inked up in a different color, then reassemble the composition when everything's inked and I'm ready to pull the print. I first figured out this method because I wanted to work in multiple colors, but didn't have the knowledge or ability to work with multiple blocks and layers. It can be limiting at times, but for the most part it works well for my subject matter.

Another crucial aspect of making my prints work is adding Speedball ink retarder to my inks, especially when working on larger pieces. Because I use water-based inks, they tend to dry out pretty fast and make it hard to print a large edition at once; however, the ink retarder prolongs the life of the ink and allows me to keep working for hours without having to worry about the longevity of the ink.

EH: What is your favorite piece that you've ever made?

LA: My most proud project yet was a block-printed poster I made for my favorite musician of all time, Gillian Welch. I have been so inspired by her music for many years, so having an opportunity to collaborate was truly special. I really connect with the visual narratives that her music evokes, so of course I enjoyed every minute of sketching, planning, carving, and printing the piece.

EH: What's the best advice you've ever been given as an artist?

LA: I think some of the most helpful advice I've been given as an artist is don't try to be like anyone else. Though I've gotten so much inspiration from other artists over the years, I've always been encouraged to find my own artistic path. Staying true to yourself and embracing your own genuine ideas provides the most creative satisfaction, plus it's what makes you stand out from the crowd.

EH: What music/books/podcasts (if any) do you like to listen to while you work?

LA: I'm always listening to music when I work. I have some go-tos like Gillian Welch, Hiss Golden Messenger, The Wood Brothers, Mandolin Orange, and The Milk Carton Kids. Some days I crave more upbeat vibes, so I'll throw on something like Stevie Wonder, Leon Bridges, Bahamas, Vulfpeck, or Emily King. Also, my husband is a musician so he's often recording at home which keeps me entertained.

Visit Lili at www.liliarnold.com

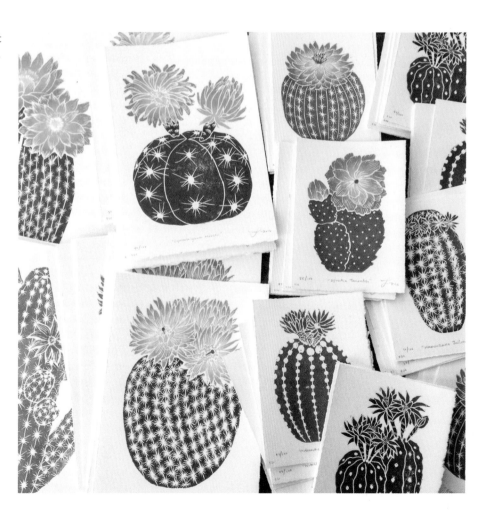

RAINBOW ROLL

Tools and Materials

- 3" x 6" (7.5 x 15 cm) rubber block
- 7" x 9" (18 x 23 cm) printing papers
- Pencil
- Ruler
- Fine-tip permanent marker
- Tracing paper
- Carving tools
- Washi/masking tape
- Inking plate
- Ink (two different colors)
- Palette knife
- Brayer
- Baren

The rainbow roll is one of the great joys of the printing process—a simple, satisfying, and lovely way to play with color in your prints. In fact, I challenge you to pull a rainbow roll and not smile—it simply cannot be done! In this project, you'll practice blending two inks together to create a smooth gradation, or transition, between two colors.

REMEMBER: Soft-Kut lives up to its name and requires nearly zero power behind a carving tool, so work slowly and deliberately, and mind your cuts. You may also want to trim away excess negative space to minimize noise.

1 Decide on the design you'll be using for this project.

2 Transfer your design onto your carving material, lock in lines with a fine-tip permanent marker, and carve out the negative space. Though I used Speedball Soft-Kut for this project, you can easily swap in mounted or unmounted linoleum according to your preferences.

3 Select a brayer that is as wide as or wider than the block. Place a small dollop each of two different colors of ink next to each other on the inking plate. (Both inks pictured here were created by blending various quantities of phthalo blue, black, and opaque white.)

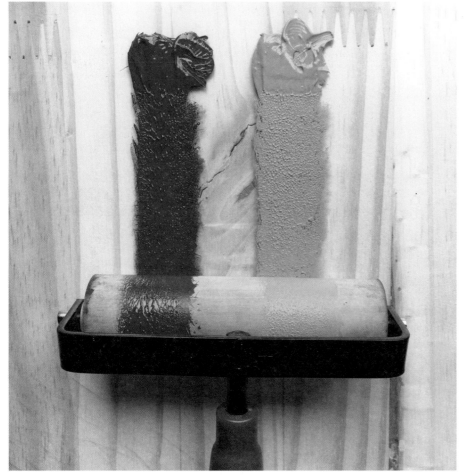

4 Use the brayer to pull the ink down. Create the smooth color transition by moving the brayer marginally to one side and then the other with each pull.

7 Carefully lay a sheet of printing paper on the inked block, using the traced rectangle as a guide. Using the baren, lightly apply even pressure on the back of the paper. Take care not to use too much pressure if using a softer rubber block, or you might cause fine details to bleed out.

5 Once you've achieved a smooth gradation, roll the brayer carefully across the block. Make a few passes if necessary, but make sure to pull the brayer in the same direction each time.

6 You can make a simple printing jig to ensure that your block will always land roughly in the same place for each print. Using a large sheet of paper, lay flat a sheet of your prepared 7" x 9" (18 x 23 cm) printing paper. Carefully trace around the perimeter of the printing paper with a sharp pencil. Remove the printing paper and place the block where you'd like the print to land. Trace the block with a sharp pencil.

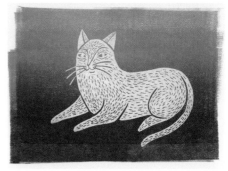

VARIATION: You can also play with using a rainbow roll as ground for your print. Simply roll the ink directly onto the printing paper. Allow the paper to dry, and then print your block on top of that.

8 Carefully peel the paper from the block. Congratulations! You've achieved a rainbow roll!

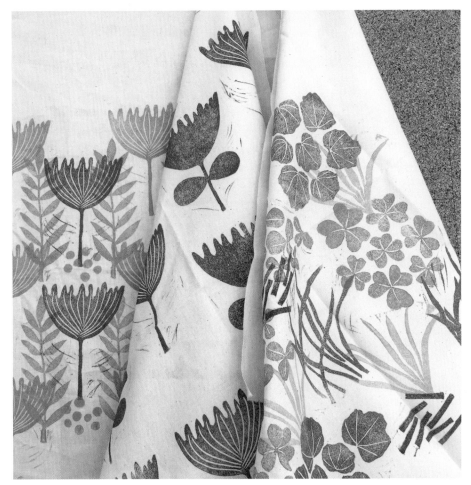

California native Jen Hewett has built a career on print from her San Francisco studio—she's a prolific printmaker, surface designer, textile artist, teacher, and author. Hewett's bright, bold prints evoke the landscape around her. In her book, *Print Pattern Sew: Block-Printing Basics + Simple Sewing Projects for an Inspired Wardrobe,* Hewett generously shares her extensive knowledge and takes readers on colorful walk through the world textile printing.

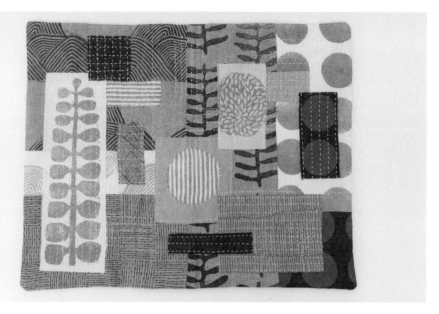

EH: What do you like about relief printing in particular?

JH: I began my printmaking life in silkscreen, which requires having access to special equipment, and spending a lot of time waiting for screens to dry. Relief printing is much more accessible; I only need carving tools and a block. Plus my hands are always busy—drawing, carving, printing. It's incredibly satisfying to have that uninterrupted connection to what I'm creating.

EH: What drew you to printing on fabric?

JH: I started working on paper, but found that the biggest pain point in sales was that customers saw prints as too much work: they'd have to frame them and figure out where to hang them. I decided to experiment with printing on linen and sewing the printed fabric into bags. Those first bags sold incredibly well so I kept developing new textile work and eventually stopped printing on paper. At the same time, I had begun to sew my own clothing and had a hard time finding printed garment fabric that I liked. It seemed natural to combine my two passions—sewing and printmaking.

EH: How do you stay creative on a day-to-day basis?

JH: I've been doing self-imposed creative challenges since 2014, when I did my 52 Weeks of Printmaking project. That year I created a new print every week. The next year I moved on to printing yardage and sewing it into a new garment every month. The past two years, I've had a Tea Towel of the Month Club. I design, screenprint, and sell a new tea towel every month, and probably spend more time on that than I need to! I also have some client work that requires me to be constantly creating. And I've finally started carving out some time to work on personal projects again.

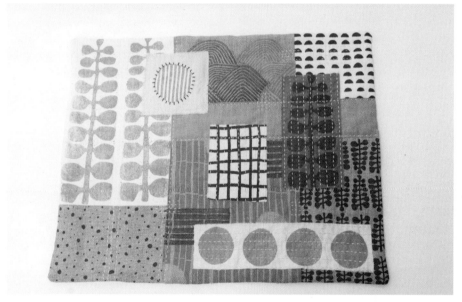

EH: How would you describe your work and/or process?

JH: I create visually layered, highly tactile printed work on fabric. Most of my work is inspired by both the natural and manmade California landscapes, and my color palette tends towards the saturated.

EH: How did you first become interested in printmaking?

JH: I was working an uncreative, corporate job, and was looking for a creative outlet. I decided to sign up for a screenprinting class at a local community center on a whim, and I was quickly hooked. Prior to my corporate job I'd had a stationery business, but I had sent the stationery designs off to a printer. With screen printing, I was able to control both the design and the production.

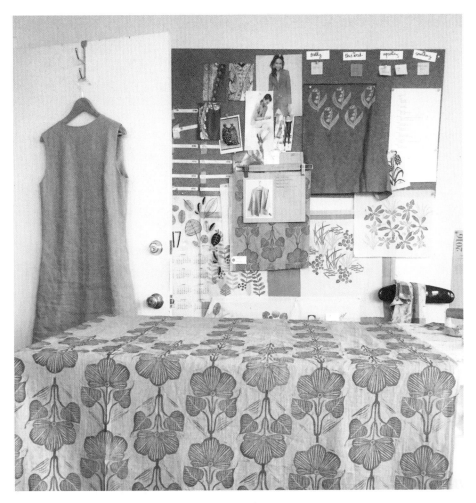

EH: Describe the space in which you make your art.

JH: I have two studios in my home! One has designated areas for drawing and computer work, sewing, and relief printing. The other studio is my tiny service porch, which I use for my screenprinting room. I do go to a shared studio a few times per month to burn my screens, and to print large-format prints, since I don't have room in my house for an exposure unit or flat drying racks.

EH: What is your favorite thing that you've ever made?

JH: I recently designed my first line of fabric with the company Cotton and Steel. My Cotton and Steel fabric is commercially printed, but my process involved scanning my hand-printed work and manipulating it digitally. I don't sell hand-printed yardage because it's so labor intensive, and I'd long wanted to create a fabric line that would be widely available, so this collection is a dream come true.

EH: What's one piece of advice you'd give to someone new to printmaking?

JH: Print a lot and print regularly! Printmaking is a physical activity, and you do develop muscle memory. I call this "thinking with your hands." Your hands tell you what direction to carve, how much pressure to apply when you print, etc. But you can't get to this point unless you are dedicated to the craft.

EH: What music/books/podcasts (if any) do you like to listen to while you work?

JH: I listen to a lot of audiobooks, preferably crime fiction. And, lately I've been really into Philip Glass's music. Much of his work almost forces its technical complexity on the listener, and it's good company when I have to work in long stretches on more complex (usually screenprinting) work. Nineties R&B and neo-soul can make printing and drawing feel like a party.

Visit Jen at jenhewett.com

PROJECT:
WALL HANGING

Textile Tools and Materials

¹/₂ yd (45.5 cm) 100% cotton duck

14" (35.5 cm) wooden dowel

Jute twine

Embroidery floss

Embroidery hoop

Needle

Fabric scissors

Liquid fray stopper

Permanent fabric adhesive

Sewing machine

Iron

Ironing board

Water-soluble fabric marking pen

Printing Tools and Materials

Ink

Baren

Inking plate

Palette knife

Brayer

This project is sort of the big-sister version of Dress Up (page 82), in that it involves a little bit of mixed media and collage, but this time instead of working on paper we'll be working on fabric. I'll take you on a "tour" of how I made this piece, highlighting techniques that you can use to make your own unique wall hanging.

Note: The intricacies of machine sewing are legion, and thus too much to cover in this little printmaking book. Some resources for sewing are located in Resources, page 150. Alternatively, many craft and fabric stores today carry premade, blank canvas banners for crafting that can be used instead of sewing your own.

Notes for Printing on Fabric

To get an even print on fabric, you might find it helpful to first lay a towel on the printing surface, creating more cushion.

The toothier, or rougher, the fabric, the less even your print will be.

For the best results, use inks that are specifically formulated to be used on fabrics—consider their permanence and solubility. Speedball makes a great line of fabric block-printing inks, but my favorite to use are Gamblin relief inks—especially Gamblin Textile Ink. Both of these inks are oil based, and so can both be washed again and again without running or losing intensity.

Always do a few test runs on paper before printing on fabric—this helps to prime the block, getting it fully loaded with ink.

Heat setting: Check the product information on the ink to find out whether or not you need to heat set the ink to make it permanent.

Allow the print on fabric to fully dry before manipulating it—otherwise you run the risk of smearing ink. To speed drying time, you can add cobalt drier to the ink before you print (using gloves!) and point a fan at the drying rack.

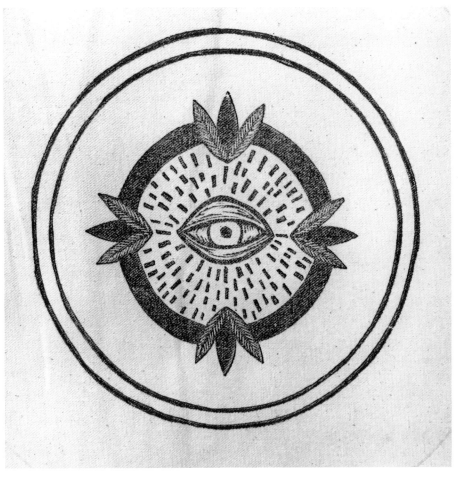

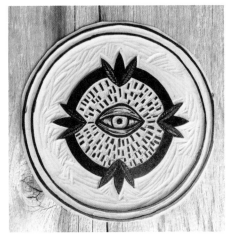

1 Iron flat a clean $^1/_2$ yard (45.5 cm) piece of unbleached cotton canvas, and then cut it in half. One half will comprise the base for your wall hanging and the other half is for experimentation and printing additional elements. I kept the design of the central block simple to allow room for improvisation and printed it in the center of the canvas.

2 Whenever I can, I like to repurpose blocks from previous projects, so I printed several additional hands from the Puzzle Block Project (page 96) onto my extra canvas and cut them out. To keep the edges of fabric sharp, clean, and unfrayed, before cutting into the fabric, "trace" around the perimeter of the image with a liquid fray stopper. Once dry, cut out the shapes just as you would if they were printed on paper. (Warning: Liquid fray stoppers can cause water-soluble inks to run, so always test first.)

3 Joining a smaller piece of fabric to a larger one is called appliqué. Traditionally, applique is done by sewing the pieces together, but here I used a permanent fabric adhesive called Liquid Stitch.

4 After placing the hands, the bulk of my design was complete. Using a water-soluble marking pen, I drew a banner shape around my image and cut it out, allowing extra room on all sides for hemming.

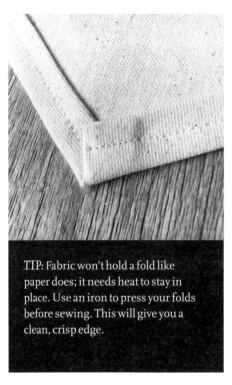

5 To hem the edge of a piece of fabric, simply fold the edge once, then again, and stitch through all layers.

6 Hem the top edge of the banner, stitching close to first fold to allow a narrow sleeve for the wooden dowel to slide through.

TIP: Fabric won't hold a fold like paper does; it needs heat to stay in place. Use an iron to press your folds before sewing. This will give you a clean, crisp edge.

A QUICK EMBROIDERY PRIMER

Embroidery is a beautiful means of hand embellishing the surface of a fabric: I like to think of it as drawing with thread. Though some consider it a tedious task, I find the practice of embroidery to be incredibly relaxing and meditative. It's easy and convenient to carry a work-in-progress around with you to pick up whenever you have a free moment.

Here are three different stitches that can be used to embellish fabric.

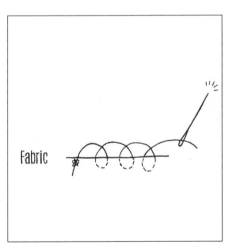

Running stitch: small, even stitches that run in and out of the cloth, and which appear like a dotted line; running stitches grouped together to fill a background are called **seed stitches.**

Split stitch: a chain stitch in which the needle is brought back through the previous stitch; it appears like an unbroken line

Satin stitch: long, straight stitches that are made parallel and close together to fill a space

7 To prepare your wall hanging for hand embellishment, place it in the embroidery hoop. The hoop is made of two circles, a smaller one fitting inside a slightly larger one with a clamp. Place the small hoop underneath the fabric and the larger hoop on top, sandwiching the fabric between the hoops. Gently pull the fabric taut like a drum and tighten the clamp to hold it in place.

8 I began my stitching with a satin stitch in the outer ring of the design, filling in the empty space with parallel stitches in an array of colors.

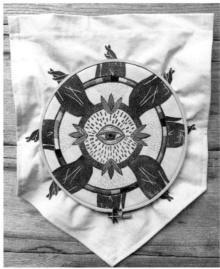

9 I added longer-length satin stitches to fill in the center of the the floral pods (gold thread). A series of running stitches grouped together make up the seed stitch, and is used for background filling.

10 Reposition the hoop as necessary according to the needs of your design.

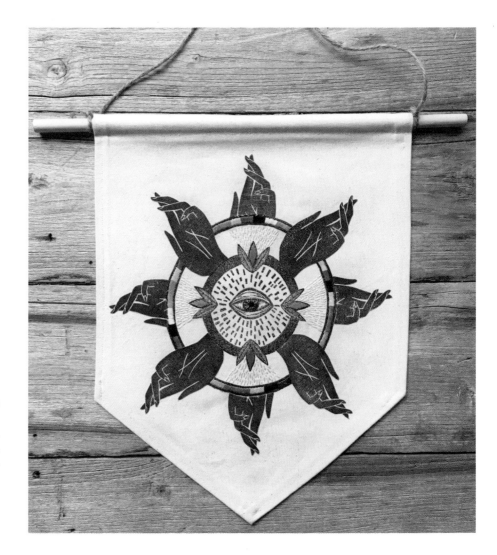

11 When finished with the stitching, remove the fabric from the hoop and lay flat to iron out any wrinkles. Slide the 14" (35.5 cm) dowel through the sleeve you created when hemming the banner (store-bought canvas banners are usually already outfitted with hanging hardware). Use a length of jute, hemp, or any other sturdy string to tie around each end of the dowel for hanging.

WASTE NOT

I've never been all that interested in perfection. The works of art that speak the loudest to my soul are always those in which the artist's hand is clearly evident. I love to search for wayward marks, cracks, odd proportions, and strange color combinations in every piece I consume because, to me, the "mistakes" are the fulcrums of magic in a given work of art. *Kintsugi* is the Japanese art of lovingly repairing broken ceramics with a special gold, silver, or platinum lacquer—essentially highlighting a mistake and turning it into something sparkling and special. These final projects are exercises in letting go of failures and embracing the imperfect nature of print.

PROJECT:
FRANKENSTEIN'S MONSTER

Tools and Materials

A small stack of failed prints

One sheet 8" x 10" (20.5 x 25.5 cm) heavyweight tagboard paper

Repositionable adhesive

Glue brush

Scissors or craft knife

Optional: needle and thread or sewing machine

Optional: tracing paper

Optional: paint kit

Optional: lightning storm

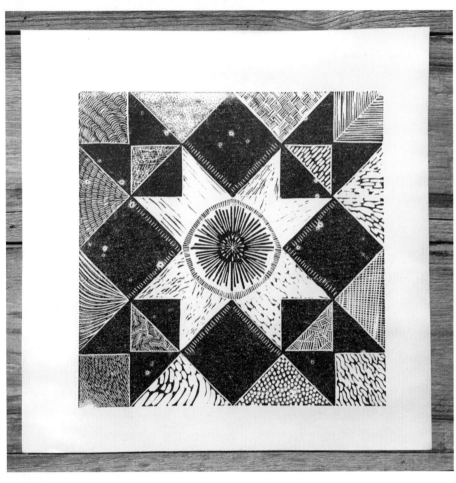

Much like the monster in Mary Shelley's *Frankenstein*, this project focuses on repurposing interesting and useful parts of failed prints to create something new and wholly unexpected. This is the perfect opportunity for experimentation and play: Because the prints you'll be using are unsuitable to edition, they are thus devoid of preciousness. That means you have complete freedom from your original intentions and how things are "supposed" to look. So use that freedom to really stretch your legs creatively; for example, if you're usually neat, orderly,

and organized, try approaching this project with wild expression. I recommend playing mad scientist in the laboratory. Cut things up, move them around, crank up the music, and work by instinct. When you land on an arrangement or pairing that makes you say to yourself, *oh that's interesting*, follow that stream wherever it takes you. Don't be surprised if you get swept up in a flood of new ideas.

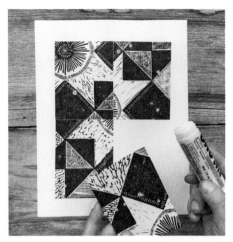

1 Because this is a collage that involves layering papers, the background is the first consideration. I used a misprint from Texture Quilt (page 50).

2 I cut the composition into four 3" x 4" (7.5 x 10 cm) rectangles, rotated them, and then pieced them together to form a 6" x 8" (15 x 20.5 cm) field of textures and values that will be the basis of the background. Glue in place on a sturdy background paper such as heavyweight tagboard.

3 As a nod to the iconic stitching used in most cinematic interpretations of Frankenstein's monster, I ran the print through my sewing machine, stitching the pieces of the background together. A similar effect can be achieved by hand sewing the paper, if preferred.

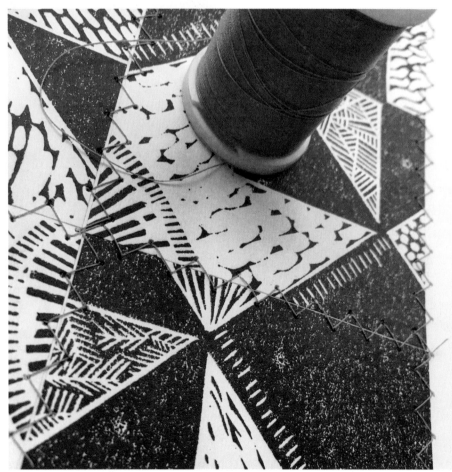

5 Use a repositionable glue, such as Nori Paste, when you start collaging elements—this will allow you to make edits as you go.

4 Cut up pieces of other misprints, according to what is most visually interesting to you. I like to use a variety of papers in my collages, but tracing paper is interesting as a somewhat analog way to play with background opacity.

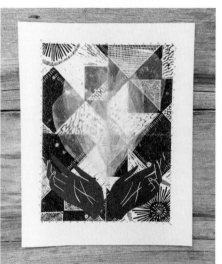

6 I used the hands from the Puzzle Block Print (page 96) as a foundation for my composition, and used layered-up pieces of tracing paper to create another space within the image. Think about ways to get your viewer's eye moving around the composition.

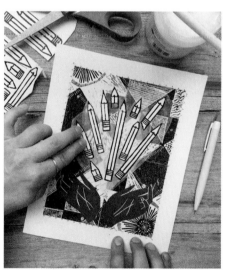

7 Cutting up pieces out of a misprint of my 2016 print *Pencils*, I arranged them within the area made by the tracing paper forms. The tracing paper tones down the "noise" of the background, keeping the pencils from getting visually lost.

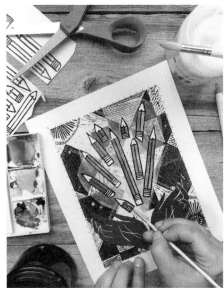

8 You can further inject life into your print—not by electrical charge via lightning but rather by paint! Use watercolor or gouache to bring color to the composition and highlight what you want your viewers to see.

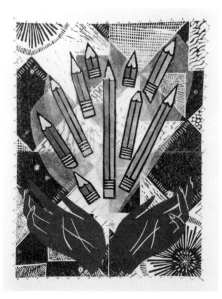

9 Part of the beauty of collage is in the mess, but no one likes a messy margin. Easily clean up the presentation of your one-of-a-kind collaged print by placing it in a mat.

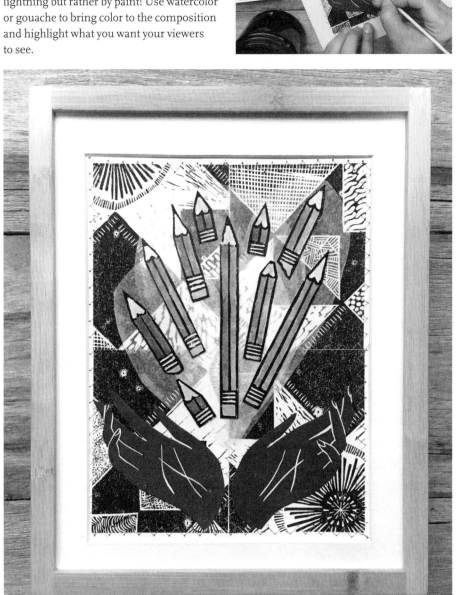

PROJECT:
WOVEN PRINT

Tools and Materials

3–4 failed prints

Scissors

Ruler

Pencil

Optional but helpful: paper cutter

Tape

This little adventure in paper manipulation is a quick and effective project for using up any misprints that might be cluttering up your drying rack or studio table. When you weave several prints together into one abstract composition, the result—turning chaos into order—is always a surprise. When choosing prints to combine for this project, I recommend looking for a range of values and textures and even colors to give the final result maximum visual variety. Now rummage through your reject pile!

1 Choose a "base" print—this will be the print that all the other prints are woven into. For ease of cutting, I recommend choosing a print with a very clear, straight border.

2 Use a ruler, pencil, and scissors or a paper cutter, to cut your base print into 1" (2.5 cm) wide strips, starting at the edge of the image. Stop as you get to the end of the image, just into the margin of the paper—don't cut any further, because you want your base print to stay in one piece.

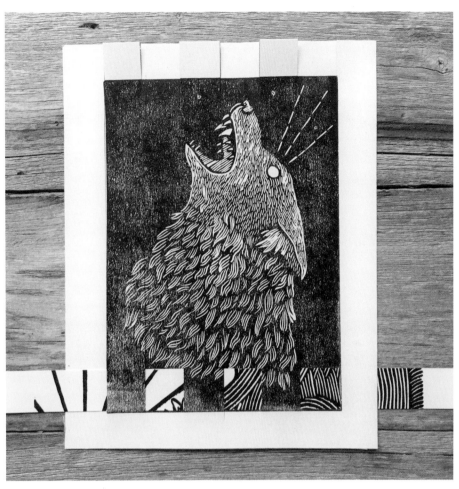

3 Cut your remaining misprints into 1" (2.5 cm) wide strips. These will be woven into the base print, alternating each strip as indicated.

4 Take one 1" (2.5 cm) strip of paper and weave it into the base print, sliding the strip all the way down to where your cuts stopped at the margin.

5 Continue weaving in the other strips, scooting each down tightly against the previous strip.

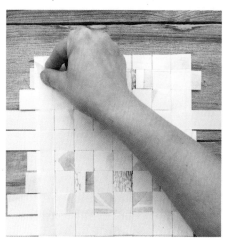

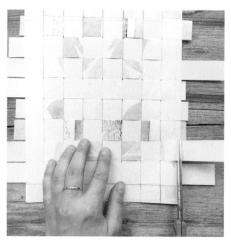

6 Stop weaving in strips once you've reached the edge of the original image.

7 Flip it over and tape strips into place.

8 Trim the excess strip lengths.

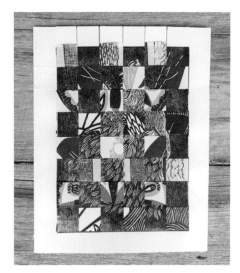

9 Trim any strips on the front of the print that fall outside of the original border.

10 In order to achieve a clean presentation, a tightly fit mat hides any less-than-perfect edges. *Voilà!* You have a one-of-a-kind print with a variety of textures both simulated (from your cuts) and real (from the woven paper).

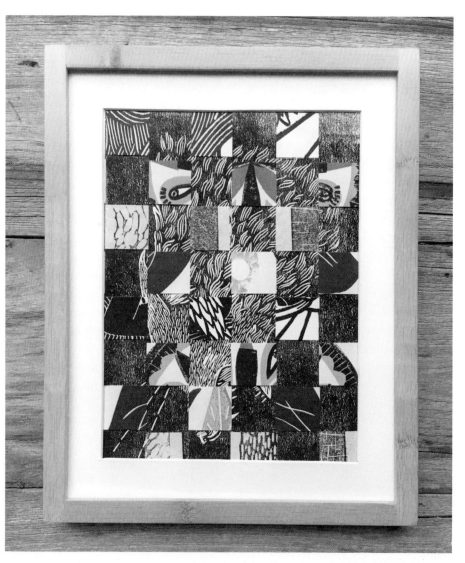

GLOSSARY

Additive: sculptural method by which elements are added to construct the form.

Appliqué: joining a smaller piece of fabric to the surface of a larger piece of fabric.

Artist's proof (AP or A/P): a print set aside from the edition for the artists' use.

Baren: a smooth, round pad either flat or slightly convex, used to apply pressure to the back of paper as it sits on an inked block.

Bench hook: a wood or metal plate with a raised lip on opposite sides of the plate, which hold a wood or linoleum block in place as you work on a tabletop.

Block: a piece of thick, flat material (usually wood, rubber, or linoleum) with a design carved onto its surface, used to print repeated impressions.

Blockbook printing: combining image and text within a single block.

Brayer: a hard or soft rubber roller with a handle, used for spreading out ink evenly and applying it directly a block.

Burnish: to rub or buff.

Burr: a rough bit of metal that can form on the edge of a blade.

Depth: the apparent distance from near to far.

Edition: a set of identical prints created by the same block that are numbered and signed. **Limited edition:** a set of prints limited in number. **Open edition:** a set of prints unlimited in number.

Embroidery: the embellishment of fabric with needle and thread

Hem: to turn under and sew the edges of a piece of fabric.

Inking plate: any surface on which you spread and roll out ink.

Mood: the overall feeling of a work of art.

Noise: extra marks on a print caused by ink hitting previously carved areas of the block; noise can be intentional or unintentional.

Print: each individual copy or impression made from a block.

Printing jig: a guide used in the registration of prints.

Reduction cut: a method of color printing in which you use the same block over and over, carving more away with each new layer of color.

Registration: any system used by printmakers to ensure that the block and paper are both in the same position for each print, usually involving the alignment of two or more blocks on a single image.

Relief: sculpture technique where elements are carved into a surface as to stand out from the background. The term comes from the Latin verb *relevo*, to raise.

Relief print: process of pulling a print from a carved block, where the ink is deposited on the remaining (uncarved) areas of the block.

Running stitch: small, even stitches that run in and out of the cloth, to give the appearance of a dotted line.

Satin stitch: long, straight embroidery stitches made parallel and close together to fill a space.

Seed stitch: a short, straight embroidery stitch used for background filling.

Space: the area in, around or between objects in a composition. **Negative space:** the area around the object/subject. **Positive space:** the area taken up by an object/subject.

Split stitch: an embroidery chain stitch in which the needle is brought back through the previous stitch to give the appearance of an unbroken line.

Subtractive (reductive): sculptural method by which material is removed to reveal the form.

Test print: the first print pulled from the block in order to determine the variables in the printing process.

Texture (or tooth): the implied physical roughness or smoothness of an object.

Unity: when the composition as a whole feels complete and harmonious.

Value: or the range of apparent lightness/darkness within an image.

RESOURCES

Books from my personal visual art library

RECOMMENDED READING

Books on Printmaking

Brommer, Gerald F. *Relief Printmaking.* Worcester, MA: Davis Publications, 1970.

Corwin, Lena, and Thayer Allyson Gowdy. *Printing by Hand: A Modern Guide to Printing with Handmade Stamps, Stencils, and Silk Screens.* New York: Stewart, Tabori, & Chang, 2008.

Hewett, Jen. *Print Pattern Sew: Block Printing Basics and Simple Sewing Projects for an Inspired Wardrobe.* Boulder, CO: Roost Books, 2018.

Hughes, Ann d'Arcy, and Hebe Vernon-Morris. *The Printmaking Bible: The Complete Guide to Materials and Techniques.* New York: Chronicle Books, 2008.

Jansdotter, Lotta, and Jenny Hallengren. *Lotta Prints: How to Print with Anything, from Potatoes to Linoleum.* New York: Chronicle Books, 2008.

Lauren, Andrea. *Block Print: Everything You Need to Know for Printing with Lino Blocks, Rubber Blocks, Foam Sheets, and Stamp Sets.* Beverly, MA: Rockport Publishers, 2016.

Morley, Nick. *Linocut for Artists and Designers.* Ramsbury, UK: The Crowood Press, 2016.

Schmidt, Christine. *Print Workshop: Hand-Printing Techniques and Truly Original Projects.* Potter Craft, 2008.

Westley, Ann. *Relief Printmaking.* New York: Watson-Guptill Publications, 2001.

Helpful Books on Drawing, Design, Creativity, and More

Archive for Research in Archetypal Symbolism (ARAS). *The Book of Symbols: Reflections on Archetypal Images.* Los Angeles: TASCHEN, 2010.

Edwards, Betty. *Drawing on the Right Side of the Brain: A Course in Enhancing Creativity and Artistic Confidence.* New York: Penguin, 1979.

Elam, Kimberly. *Geometry of Design: Studies in Proportion and Composition.* Princeton, NJ: Princeton Architectural Press, 2001.

Gilbert, Colin, Dylan Gilbert, Elizabeth T. Gilbert, Gabriel Guzman, Rebecca J. Raso, Sharon Robinson, Amy Runyen, and David J. Schmidt. *The Daily Book of Art: 365 Readings that Teach, Inspire & Entertain.* Lake Forest, CA: Walter Foster Publishing, 2009.

Gilbert, Elizabeth. *Big Magic: Creative Living Beyond Fear.* New York: Riverhead Books, 2016.

Korn, Peter. *Why We Make Things and Why it Matters: The Education of a Craftsman.* Boston: David R. Godine, 2013.

Martha Stewart Living Magazine. *Martha Stewart's Encyclopedia of Sewing and Fabric Crafts: Basic Techniques for Sewing, Applique, Embroidery, Quilting, Dyeing, and Printing, plus 150 Inspired Projects from A to Z.* New York: Potter Craft, 2010.

Parks, John A. *The Pocket Universal Principles of Art: 100 Key Concepts for Understanding, Analyzing and Practicing Art.* Beverly, MA: Rockport Publishers, 2018.

Ray, Aimee. *Doodle-Stitching: Fresh & Fun Embroidery for Beginners.* New York: Lark Books, 2007.

Sale, Teel, and Claudia Betti. *Drawing: A Contemporary Approach.* Boston: Thomson Wadsworth, 2008.

Great Periodicals for Staying Up to Date with Contemporary Artists and Getting Seriously Inspired

Pressing Matters Magazine
www.pressingmattersmag.com

UPPERCASE Magazine
uppercasemagazine.com

Maker's Magazine
makersmovement.ca

Celebrating Print
www.celebratingprint.com

Art 21 Magazine
magazine.art21.org

SOURCES FOR PURCHASING MATERIALS USED IN THIS BOOK

Dick Blick Art Supplies
www.dickblick.com

McClain's Printmaking Supplies
www.imcclains.com

Speedball Art Supplies
www.speedballart.com

Plaza Artist Supplies
www.plazaart.com

Utrecht Art Supplies
www.utrechtart.com

Woodcraft Woodworking Tools
www.woodcraft.com

Artist & Craftsman Supply
www.artistcraftsman.com

Jackson's Art Supplies
www.jacksonsart.com

Paper Mojo
www.papermojo.com

The Japanese Paper Place
www.japanesepaperplace.com

Spines of *UPPERCASE magazine*—you don't even have to open one to get inspired! (But please do, you won't regret it.)

ACKNOWLEDGMENTS

ABOUT THE AUTHOR

Many people contributed to this little volume of magic. Thanks are due first and foremost to my generous editor Judith, who kept me encouraged and focused throughout the writing process and to Rockport Publishers, who transformed me from an artist into an author—a lifelong dream. To my contributors Lili Arnold, Jen Hewett, Kelli MacConnell, Derrick Riley, and Aftyn Shah—thank you for giving us glimpses into your work, your spaces, and your hearts.

My life has been touched by a great many teachers who, like most, sacrifice much for the benefit of the next generation. My public education in Kentucky set me on a path of lifelong curiosity with the guidance of passionate, talented teachers like Terri Schatzman and Roberta Schultz. Many thanks to the art department faculty and staff at the University of Kentucky and the University of Cincinnati who allowed me to flourish in their programs.

Thanks especially (and again) to Derrick Riley, my teacher and friend, for getting me into this mess.

Thank you to my incredible support system of family and friends, namely my parents for believing in me before I ever believed in myself, for teaching me to read, for encouraging my strangeness and nurturing my curiosity. This book wouldn't exist if you hadn't loved me so very well. Thanks also to the fiercely loving gang of girlfriends who were by my side throughout this process, especially Kyle and "The Aunties"—if I shine, it's only because I'm reflecting your light. And to David...thank you for everything.

Emily Louise Howard is a printmaker and illustrator born in Burlington, Vermont, and reared in Erlanger, Kentucky. Identifying as an artist since the tender age of seven, she has spent her life in the pursuit of visual expression and storytelling. Emily earned her undergraduate degree from the University of Kentucky and earned two master's degrees in Fine Arts and Visual Art Education from the University of Cincinnati. Having spent a few enriching years as a public school art teacher in northern Kentucky, Emily is now a full-time printmaker who runs her one-woman fine art printmaking business and studio practice, The Diggingest Girl, from her home studio with the help of her cat, Selu. Emily's feminine, narrative prints are collected internationally and inspired by the natural world, the human body and stories of all kinds.

Follow along with Emily's printmaking journey through her website: www.thediggingestgirl.com

For a more intimate look into the daily life of a printmaker, see Emily's work on Instagram as @thediggingestgirl.

INDEX